AMERICAN ART

AMERICAN ART

General Editor
Francesco Abbate

Translated by
Simon Coldham

Octopus Books
London · New York · Sydney · Hong Kong

English version first published 1972 by
Octopus Books Limited
59 Grosvenor Street, London W1
Translation © 1972 Octopus Books Limited

Distributed in Australia by
Angus & Robertson (Publishers) Pty Ltd
102 Glover Street, Cremorne, Sydney

ISBN 7064 0028 3

Originally published in Italian by
Fratelli Fabbri Editore
© 1966 Fratelli Fabbri Editore, Milan

Printed in Italy by Fratelli Fabbri Editore

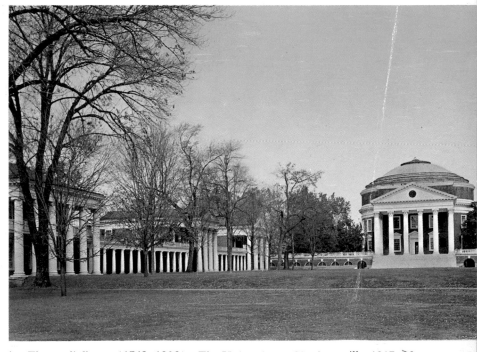

1 *Thomas Jefferson (1743–1826) : The University at Charlottesville, 1817–26.*

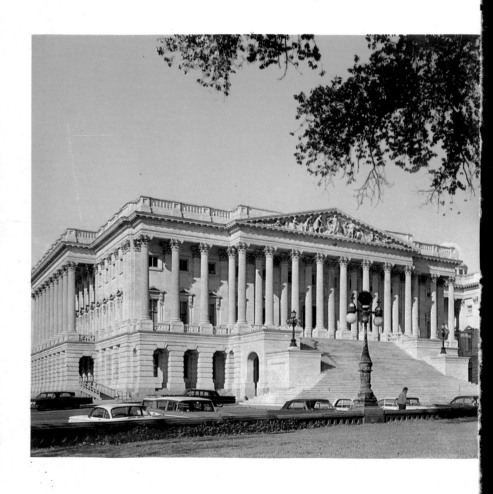

CONTENTS

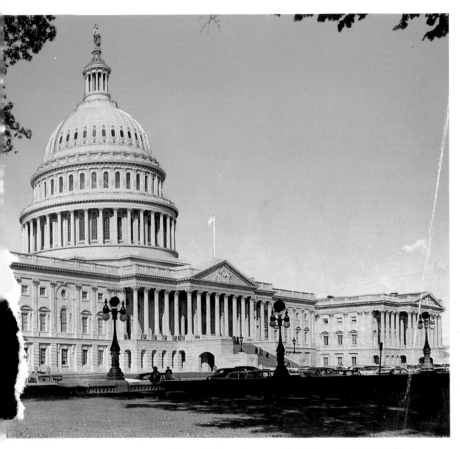

2 *William Thornton (1759–1828), Thomas U. Walter (1804–1887), Charles Bulfinch (1763–1844) and others: The Capitol at Washington, 1792–1865.*

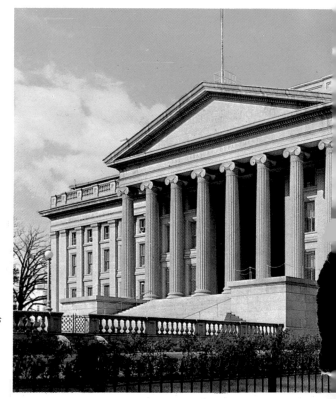

3 *Robert Mills*
(1781–1855):
The Treasury
Building in
Washington,
1836–42.

NINETEENTH-CENTURY ART IN THE UNITED STATES

Whereas the history of western art had been hitherto almost exclusively linked with European history, its boundaries extended in the nineteenth century to embrace the art of a young nation which had recently become an independent republic and soon emerged as a world power of considerable political and economic importance – the United States of America. This new republic, unfettered by past traditions and concentrating all its abundant energies on the future, was capable of the highest achievements in every artistic field.

Yet the very absence of tradition, especially in the cultural and artistic fields, was a source of concern to the Americans, who saw it as a vital deficiency. This led them to devote all their enthusiasm and admiration to the cultural and artistic inheritance of ancient Europe in all its forms and to try to assimilate it, to make it their own. The tendency was encouraged by the fact that America con-

sisted largely of groups of European immigrants who had brought to their new country the customs, the traditions, the fashions, even the artistic styles of their countries of origin.

While a rather passive dependence on European models characterizes the first timid artistic enterprises of the eighteenth century, the nineteenth century in the United States saw a rather freer adaptation of European ideas and, in the field of architecture, the birth of a completely original school. Thus by the end of the century the United States already showed signs of having developed an independent artistic tradition which was, in the twentieth century, to prove itself the most mature and the most influential in the world.

In the late eighteenth century, under the influence of French and English models, neo-classicism was already being adopted in north-American architecture with a very high degree of success. This style, which stems from a profound admiration for the ancient Greek and Roman civilizations, is also typical, as in Europe, of buildings of the first decades of the nineteenth century and clearly reflects the influence of the various American architects who had gathered experience in London, Paris or Rome, while travelling in Europe.

Moreover the adoption of neo-classicism was particularly enthusiastic in the United States, for this new nation cherished the links, sentimental and idealistic, that connected it with the ancient classical civilizations. Both the Roman republic and the Greek city-states were seen as perfect, unsurpassed examples of societies based on those democratic principles which had provided the cornerstone of the American Revolution.

1 Thomas Jefferson (1743–1826): *The University* at Charlottes-ville, 1817–26.

At the Charlottesville University, Jefferson demonstrated an obsession with classical architecture which subsequently spread throughout America; each building is an almost perfect copy of a classical building. The library, for instance, is modelled on the Pantheon.

2 William Thornton (1759–1828), Thomas U. Walter (1804–87), Charles Bulfinch (1763–1844) and others: *The Capitol* at Washington, 1792–1865.

The Capitol is possibly the most famous neo-classical achievement in America, a symbol of its new position in the world. Many architects contributed to it, work starting on it in 1792. Although the central section was finished in 1828, it was not completed until 1865.

3 Robert Mills (1781–1855): *The Treasury Building* in Washington, 1836–42.

Although the most important American architects of the time were brought up in the European historical tradition, they used only those elements of neo-classicism which were consistent with basically practical values. This is exemplified by this building by Mills, its large projecting porch happily combining neo-classical and modern characteristics.

4 William Clarke: *Insane Asylum* at Utica, 1837–43.

This absolute faith in neo-classical ideas cannot simply be attributed to the effect of contemporary European culture; it is also, in a sense, a uniquely American reaction, which makes use of the achievements of this ancient classical tradition in order to satisfy its own yearnings for splendour and greatness.

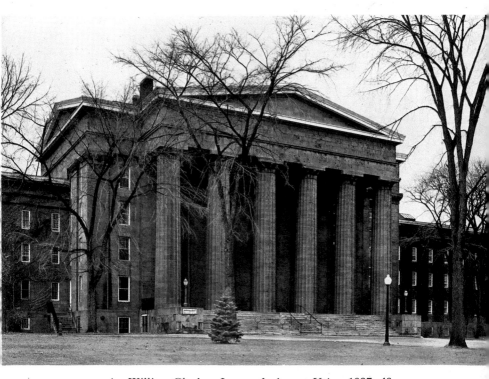

4 *William Clarke : Insane Asylum at Utica, 1837–43.*

For these sentimental reasons, Thomas Jefferson built, between 1817 and 1826, the University of Virginia at Charlottesville, using white marble, combining Doric and Corinthian styles and borrowing from Roman architecture the idea of a central plan. In spite of its stylistic eclecticism, Jefferson's work is redeemed, from an aesthetic point of view, by its fine sense of porportion and the harmonious articulation of its forms. Many other architects were to follow his example.

In the eighteenth century, Pierre-Charles L'Enfant undertook the planning of Washington, the capital of the United States, which today contains more neo-classical buildings than almost any other American city. At the beginning of the nineteenth century, William Thornton built the central part of the Capitol and Thomas U. Walter later added the wings and the imposing dome which rests on two rows of columns.

Robert Mills designed the Treasury building with its broad façade and its projecting portico consisting of a row of Ionic columns beneath a large, undecorated pediment. Mills's passionate belief in the purity of Greek forms was shared by William Strickland, who drew up the central plan of the Merchants' Exchange in Philadelphia, and also by Parris and Benjamin, the two principal New England architects; Benjamin's numerous writings on the subject also helped to disseminate his views in support of Greek architecture.

In the southern States of the United States, where colonialism had created a way of life completely different from that of the democratic, industrial North, the neo-classical style was used in the designing of plantation houses, the homes of landowners; but their comfortable,

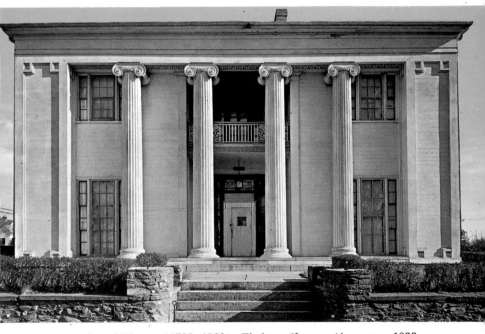

5 *Russel Warren (1783–1860) : Elmhyrst House at Newport, c. 1833.*

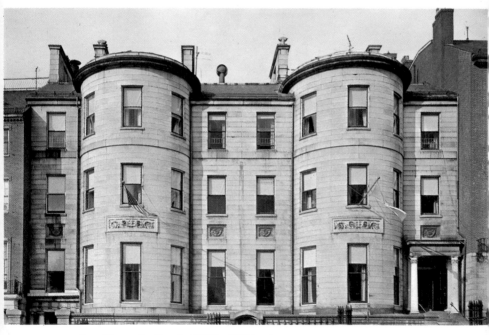

6 *Alexander Parris (1780–1852) : David Sears House at Boston, 1816.*

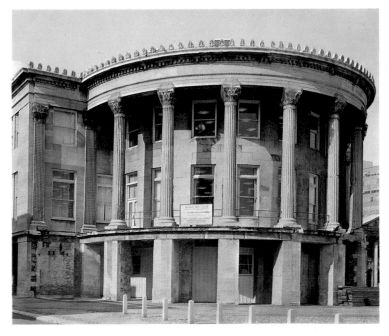

7 *William Strickland (1788–1854) : Merchants' Exchange at Philadelphia, 1832–4.*

5 Russel Warren (1783–1860): *Elmhyrst House* at Newport, *c.* 1833.
Here the neo-classical style is used to design a private house, with its superbly proportioned façade, Ionic columns and unadorned architrave. Classical forms are used without giving any sense of academism.

6 Alexander Parris (1780–1852): *David Sears House* at Boston, 1816.
An example of a private house of the early nineteenth century. Here practical requirements supersede neo-classical ideas, a trend that was to continue throughout the second half of the nineteenth century.

7 William Strickland (1788–1854): *Merchants' Exchange* at Philadelphia, 1832–4.
The semi-circular façade, with its columns rising above a colonnade, make this one of Strickland's most important and interesting buildings.

8 McKim, Mead and White: *Isaac Bell House* at Newport, 1881–2.
By covering the exteriors of private houses with strips of wood, architects achieved a sense of rustic simplicity, though the originality of these buildings lies in the utter freedom of their design.

9 McKim, Mead and White: *Detail of the Isaac Bell House* at Newport, 1881–2.
This view of the Bell House demonstrates the nature of the 'shingle style', involving the use of strips of wood to cover the surface of a building.

10 American School: *First Unitarian Church* at Salem, 1836–7.
Here the architect clearly intended to recreate the Gothic concept, though he has interpreted it in a rather free fashion without keeping too closely to the old architectural norms.

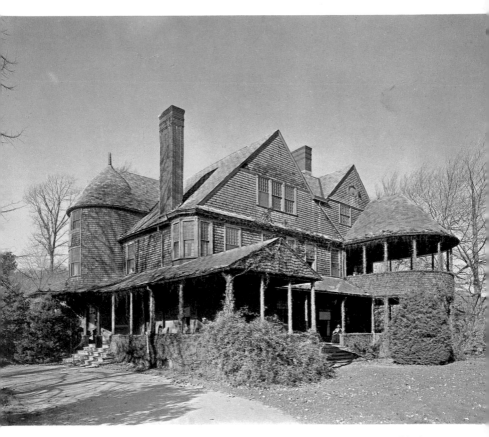

8 *McKim, Mead and White: Isaac Bell House at Newport, 1881–2.*

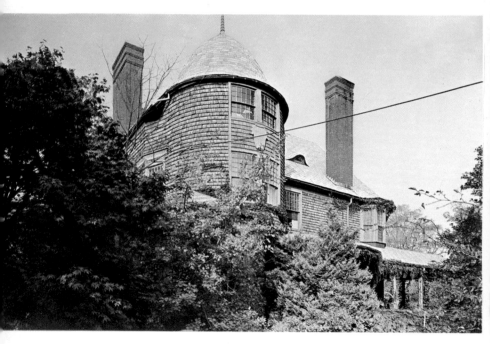

9 *McKim, Mead and White: Detail of Isaac Bell House at Newport, 1881–2.*

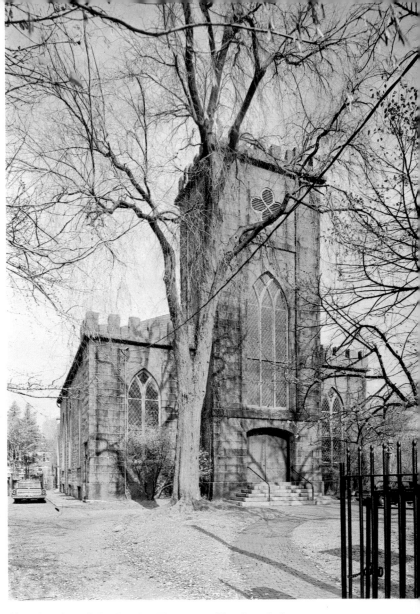

10 *American School : First Unitarian Church at Salem,*
1836–7.

unassuming appearance contrasts greatly with the rhetorical grandeur typical of the buildings of Washington, Utica and Philadelphia.

With the rapid development of the American people, with their greater emphasis on concreteness and practicality, and their realistic hopes for the future, architecture was bound to change. Private houses now had to be practical and elegant at the same time, in keeping with the ideas of a captain of industry. Public buildings had to be designed in a manner that was functional but gave an appearance of grandeur corresponding to their importance. A hotch-potch of various styles, all imported from Europe, was used during this period, an uncertain, intermediate phase which eventually led to the superb, original achievements of the Chicago School.

Meanwhile the 'shingle' style began to be used for private houses, especially summer-residences in the country. This technique, which consists of using strips of wood to outline buildings, resolved the conflict between the various constituent styles, giving a coherence, a sense of unity to the different parts of the building. This style is one of the most original discoveries made in American architecture around the middle of the century and it was used by Bruce Price, William Emerson and Wilson Eyre, as well as by McKim, Mead and White, who formed the earliest important architectural partnership.

A considerable freedom of expression and a sure sense of the demands of the environment are characteristic of buildings in the shingle style, of which the Isaac Bell House at Newport, designed by McKim, Mead and White, is a particularly pure and authoritative example.

The Gothic revival was of rather marginal importance,

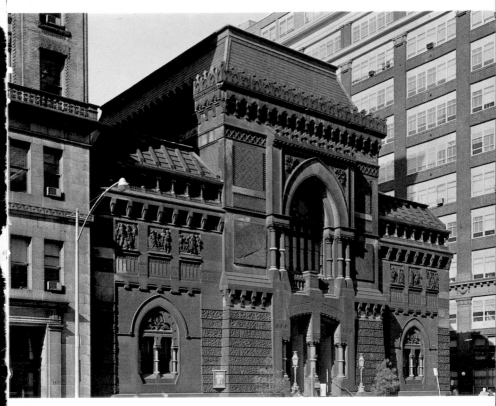

11 *Frank Furness (1839–1912) : Fine Arts Academy in Philadelphia, 1872–6.*

25

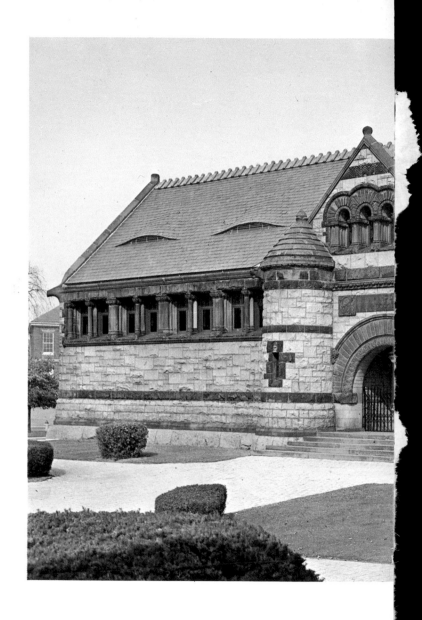

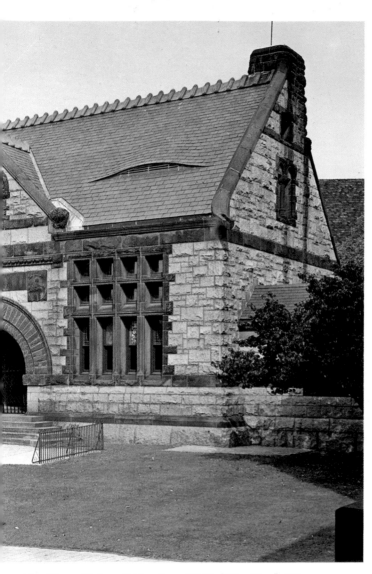

12 *Henry Hobson Richardson (1838–86) : Crane Library at Quincy, 1880–3.*

13 *Henry Hobson Richardson (1838–86) : Stoughton House at Quincy, 1882–3.*

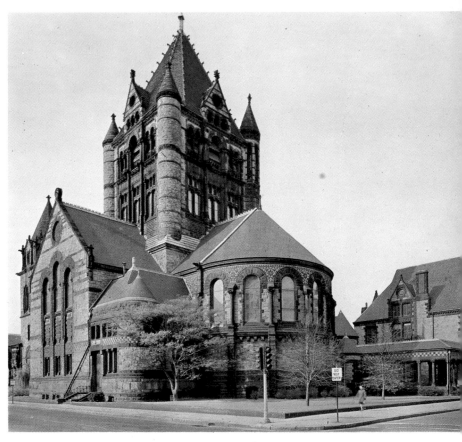

14 *Henry Hobson Richardson (1838–86) : Trinity Church in Boston,
1873–7*

11 Frank Furness (1839–1912): *Fine Arts Academy* in Philadelphia, 1872–6.
Here Gothic features are restricted to the exterior, as though the architect had forced himself to add the usual pointed arches and other decorative Gothic characteristics to an existing building.

12 Henry Hobson Richardson (1838–86): *Crane Library* at Quincy, 1880–3.
This library built by Richardson at Quincy in Massachusetts shows a few Romanesque features introduced into an absolutely original design.

13 Henry Hobson Richardson (1838–86): *Stoughton House* at Quincy, 1882–3.
This house is built in the 'shingle' style, like many others of the period. Henry Hobson Richardson interpreted this style in a very individual manner.

14 Henry Hobson Richardson (1838–86): *Trinity Church* in Boston, 1873–7.
Richardson preferred the solid qualities of Romanesque architecture to the Gothic mannerisms of so much of the work of his contemporaries. This church dates from early in the career of a man who was later to produce some of the most important nineteenth-century architecture in America.

15 Henry Hobson Richardson (1838–86): *Alleghany County Court House and Jail* at Pittsburgh, 1884–8.
Richardson was influenced by British and European architectural traditions. One of the most gifted architects of the age, his most outstanding successes were his designs for public buildings.

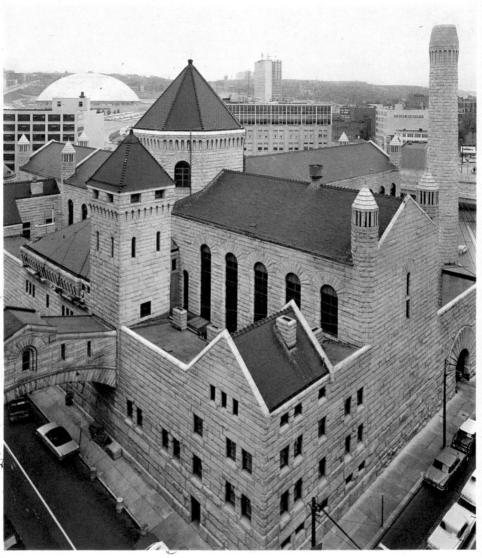

15 *Henry Hobson Richardson (1838–86) : Alleghany County Court House and Jail at Pittsburgh, 1884–8.*

though it reached America from Europe at this time and appealed to a certain romantic mood then prevalent. However, among the numerous naive imitations of Gothic buildings, especially English ones, there are a few examples of Gothic features being elaborated in an interesting manner – the Salem Cathedral in Massachusetts, for instance, and the Provident Life and Trust Company of Frank Furness at Philadelphia, where Gothic arches and three-cusped windows were extensively used to decorate immense buildings whose inspiration was basically nineteenth-century.

Henry Hobson Richardson, one of the most attractive architects of the nineteenth century, was partially influenced by the Gothic revival, though only in his early years; but after studying for a long time in France at the École des Beaux-Arts, he returned to America brimming over with completely new ideas. His first churches, at Boston and Springfield, show that he was more drawn to the solid qualities of the Romanesque style than to the vertical, more delicate elegance of the Gothic. He had a deep and precise understanding of matter, of the use of powerful masses and their latent energy, but at the same time he remained realistically aware of the needs and demands of his society and age. His buildings became increasingly more modern, indeed quite revolutionary, in their conception.

Richardson found in Romanesque architecture the key to a genuine and simple form of expression and he rediscovered the possibilities of the rough stone, of those simple, functional forms and unadorned façades which suit the New England landscape so well. Fully conscious of the new needs of the United States, he also designed bridges,

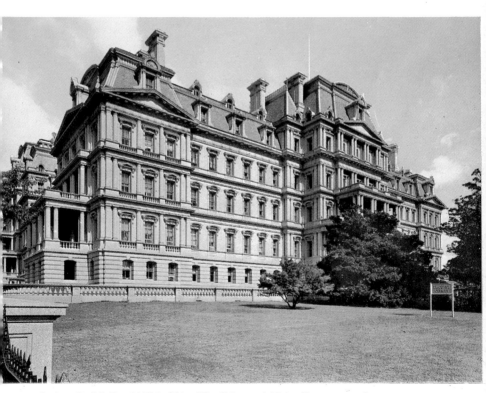

16 *Arthur B. Mullet (1834–90) : The War and Navy Department in Washington, 1871–5.*

16 Arthur B. Mullet (1834–90): *The War and Navy Department* in Washington. 1871–75.
This is a typical example of the Second Empire Style in a vast imposing building which combines classical and Renaissance features.

17 William Le Baron Jenney (1832–1907): *Leiter Building* in Chicago, 1889–90.
This building was built in collaboration with William Bryce Mundie and is now occupied by Sears, Roebuck and Company.

18 Charles B. Attwood (1849–95): *World's Fair, Fine Arts Building* in Chicago, 1892–3.
Attwood was invited by Burnham in 1891 to take the place of his colleague Root in designing buildings for the Chicago Exhibition, known as the World's Fair.

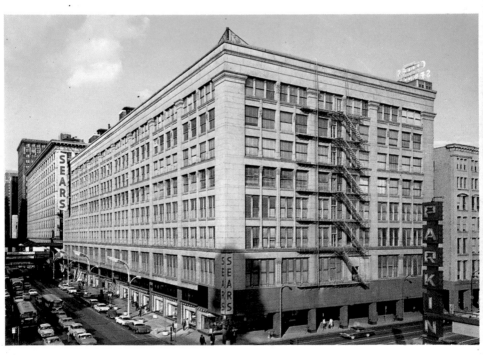

17 *William Le Baron Jenney (1832–1907) : Leiter Building in Chicago, 1889–90.*

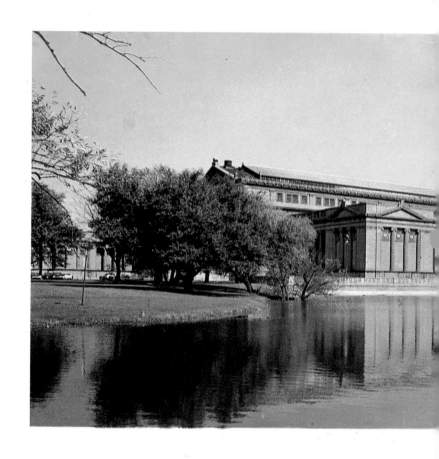

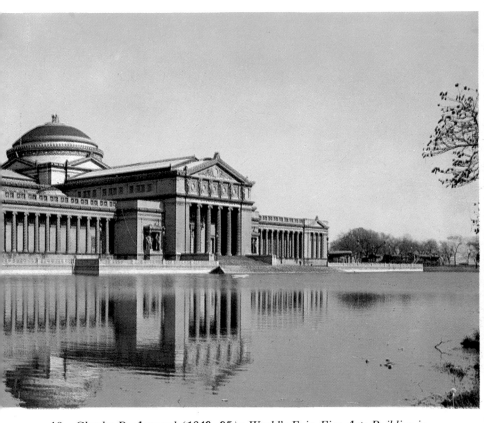

18 *Charles B. Attwood (1849–95) : World's Fair, Fine Arts Building in Chicago, 1892–3.*

railways and viaducts. Later, when he became famous, he built at Chicago the first really rationally planned commercial buildings, showing just how successfully enormous masses can be manipulated.

In 1871 a large part of Chicago was destroyed by fire and its subsequent reconstruction was undertaken by a group of architects who shared certain clearly defined and modern ideas and together made up what is known as the Chicago School. One of their forerunners was the New York architect, Bogardus, who had already been using metal structures around the middle of the century and who had designed the pavilion for the 1853 World Exhibition, using a circular plan and roofing it with sheet-iron, supported by steel cables which join together at the top of a central column. The use of a steel framework was the great discovery of the Chicago School, for whom architecture was both the servant of industry and the child of the Industrial Revolution.

The Leiter Building of William Le Baron Jenney typifies the new theories which stressed the harmonious effects that could be achieved by using basic, cubic forms and plain, unbroken surfaces. Jenney's other works, together with those of Holabird and Roche and of John Wellborn Root, followed the same trend, welcoming the new materials which technical progress had made available and the immense possibilities they offered. Though their aims might have been utilitarian, the best architects produced works whose unity, fine sense of proportion and harmonious effect entitle them to the highest artistic consideration.

It was particularly true of Louis Henry Sullivan, the master-mind of this movement which took place towards

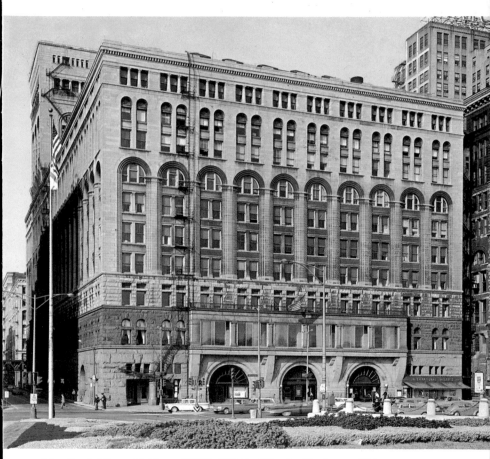

19 *Louis Henry Sullivan (1856–1924) : The Auditorium at Chicago, 1887–9*.

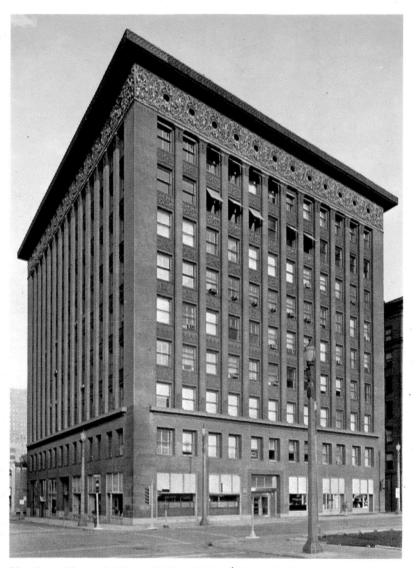

20　*Louis Henry Sullivan (1856–1924): Wainwright Building at Saint Louis, 1890–1.*

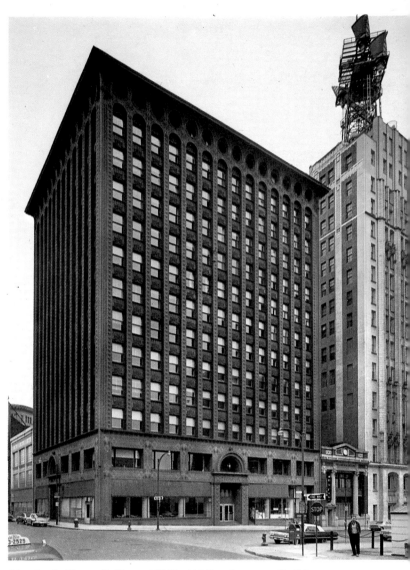

21 *Louis Henry Sullivan (1856–1924) : Guaranty Building at Buffalo, 1894–5.*

19 Louis Henry Sullivan (1856–1924): *The Auditorium* at Chicago, 1887–9.

The auditorium was part of a vast scheme, including a hotel and office blocks, and was built by Sullivan in collaboration with the engineer, Adler, who had become his partner in 1881.

20 Louis Henry Sullivan (1856–1924): *Wainwright Building* at Saint Louis, 1890–1.

The Wainwright Building is the first example of a skyscraper. Its emphatic, vertical upthrust and the increased number of storeys make it impossible to distinguish the various levels. Only the top storey stands apart as a result of its different dimensions and varied decoration.

21 Louis Henry Sullivan (1856–1924): *Guaranty Building* at Buffalo, 1894–5.

Sullivan's principle was 'Function precedes Form', but by the word 'function' he did not mean anything mechanical; he implied rather the vital spirit of the building.

22 Louis Henry Sullivan (1856–1924): *Gage Building* at Chicago, 1898–9.

Here Sullivan tried for the first time to accentuate the height of the skyscraper by dividing its surface and breaking it up in order to diminish the effect of height.

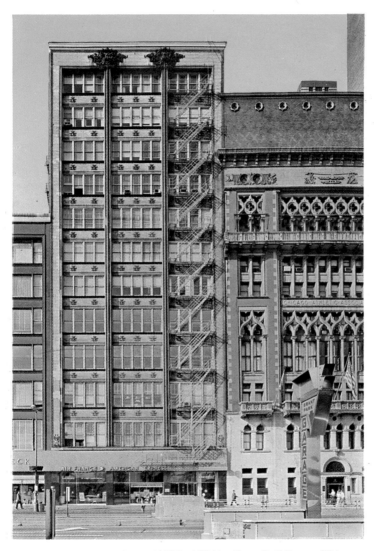

22 *Louis Henry Sullivan (1856–1924) : Gage Building at Chicago. 1898–9*.

the end of the nineteenth century. He studied in an atmosphere predominated by the Chicago School, showing interest in Richardson's later work and spending some time in Paris in order to broaden his experience. When he started work, however, he was not content merely to elaborate other people's ideas and asserted his own personality, introducing innovations in spatial organization; his Wainwright Building at Saint Louis, whose confident vertical movement enhances its spatial qualities, was the first real skyscraper. In his subsequent works Sullivan reduced the vertical upthrust in favour of a balance between the vertical and the horizontal elements, and the office block, the emblem of American industrial civilization, received from him its final, definitive form.

There are some similarities between Sullivan's ideas and Art Nouveau, but the decorative features which he used, in moderation, to embellish his façades, did not constitute an integral part of the building and did not serve any practical function, as was the case in the work of Van de Velde and Mackintosh; on the contrary, they are deliberate additions to otherwise complete and self-sufficient structures. Sullivan's work was not continued by his immediate successors, and thirty years were to elapse before American architects became interested in his achievements and appreciated what he had to teach them.

While scarcely a single interesting work of sculpture was produced throughout the whole century, the history of painting is much more rewarding, though hardly comparable to the great architectural achievements. Even in the second half of the eighteenth century we find a few good American painters who show a certain originality in spite of their obvious dependence on European models –

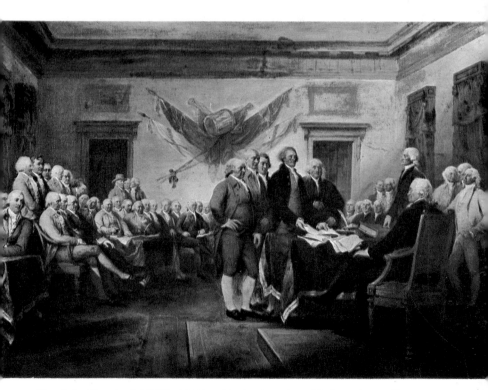

23 *John Trumbull (1756–1843) : The Declaration of Independence. New Haven, Yale University Art Gallery.*

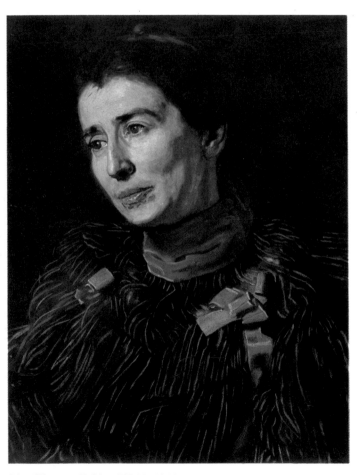

24 *Thomas Eakins (1844–1916) : Portrait of Addie, c. 1900.*
Philadelphia Museum of Art.

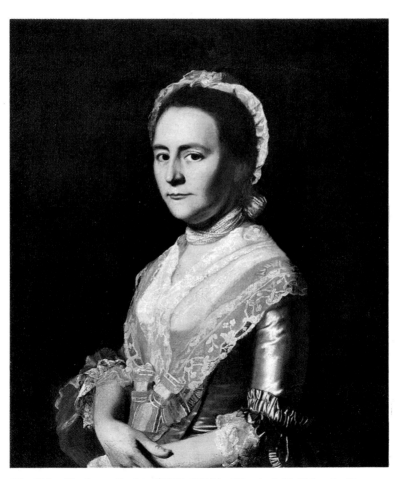

25 *John Singleton Copley (1738–1815) : Elizabeth Goldthwait. New York, Brooklyn Museum.*

23 John Trumbull (1756–1843): *The Declaration of Independence*. New Haven, Yale University Art Gallery.
The majority of the forty-three people who appear in this picture were painted in the flesh. Only in a few cases was Trumbull forced to rely on existing portraits, on verbal descriptions or on his own memory.

24 Thomas Eakins (1844–1916): *Portrait of Addie. c.* 1900. Philadelphia Museum of Art.
A prolific portrait-painter, Eakins was more interested in anatomical details than in aesthetic theories.

25 John Singleton Copley (1738–1815): *Elizabeth Goldthwait*. New York, Brooklyn Museum.
In the large number of portraits which he painted, Copley made use of ideas which he had collected during his travels in Europe. His search for purely formal beauty tended to ossify the naturalistic effects of what he observed.

26 George Caleb Bingham (1811–1879): *Fur-traders on the Missouri*. 1845. New York, Metropolitan Museum of Art, Morris K. Jessup Fund.
This work, painted before Bingham's election to the Missouri legislature, precedes his 'political' pictures.

27 John Peto: *Still life with lamps*. New York, Brooklyn Museum.
Before Impressionist painting after the French model became widely known throughout America, many artists, including John Peto, painted pictures which were inspired by a mixture of realism and romanticism.

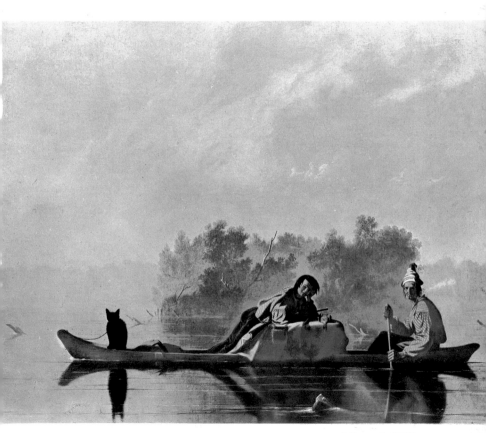

26 *George Caleb Bingham (1811–79) : Fur-traders on the Missouri. 1845.*
New York, Metropolitan Museum of Art.

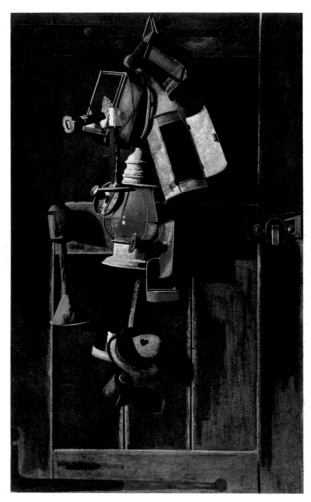

27 *John Peto: Still life with lamps. New York,*
Brooklyn Museum.

Gilbert Stuart, for instance, or that precise portrait-painter, John Singleton Copley.

In Europe, nineteenth-century historical painting remained within the restrained classical idiom and even quite recent events were endowed with the poetic solemnity of the ancient myths. In the United States, however, the particular cultural atmosphere combined with the Americans' keen interest in contemporary events enabled painters to depict these events in a vivid manner without recourse to classical allusions. In the first half of the nineteenth century some gifted landscape-painters emerged – Washington Allston, Samuel Morse and, most important of all, the Hudson River School, with which Thomas Cole and Asher Durand were connected. These two painters were rather literary in the representation of nature, though their powers of evocation were not inconsiderable.

It is possible to recognize in American landscape-painting the main currents of contemporary European art, although they were interpreted in such a modest fashion as to make it difficult to talk of any real similarity. Thus Romanticism consisted of placing obscure, fantastic objects in the landscape and Naturalism is typified by the realistic, rather naive subject-matter of John Neagle.

American still-life painting was, however, more interesting, especially the work of Raphaelle Peale and his highly gifted successor, William Harnett. In Harnett's work, and particularly in that of John Peto, the painter's delight in transforming everyday objects, like lamps and hunting equipment, leads him to a brilliant use of optical illusion, to the creation of almost *trompe-l'oeil* effects.

Throughout the century paintings inspired by the wild

and dangerous lives of the pioneers and the Indians were very successful. Although the execution of these pictures was simple and unsophisticated, they were inspired by genuine emotions, aroused by these exciting tales of adventure and by dreams of a land where nature was still untamed and unspoilt. George Catlin and George Caleb Bingham are among the representatives of this school.

After 1860, the school of landscape-painting began to flourish under the influence of William Page and George Inness, who had become familiar with the Barbizon School in France and shared their views on painting. But it was Winslow Homer, the first really original American landscape-artist, who had the greatest effect on this *genre* of painting. He drew his inspiration from a careful observation of his native land, which he lovingly depicted in paintings which are unrestrained, full of air and light.

The work of Albert Pinkham Ryder, one of the most interesting figures in nineteenth-century American painting, is a complete contrast. Ryder, who continued to paint until the second decade of the twentieth century, developed a dreamy, visionary insight unparalleled among his contemporaries. On his canvases the landscape is plunged in a twilight gloom which quivers with hidden menace and his unreal images, full of mysterious allusions, were later to have an important influence on the Surrealists.

While Ryder's links with European painting were rather tenuous, John Sargent was closely affected by French and Italian cultural traditions, which he learned to appreciate in the course of the frequent visits he paid these two countries. He was a fashionable portrait-painter, of a rather free and whimsical nature, who clothed his subjects in sharp, vivid colours and surrounded them with an atmosphere

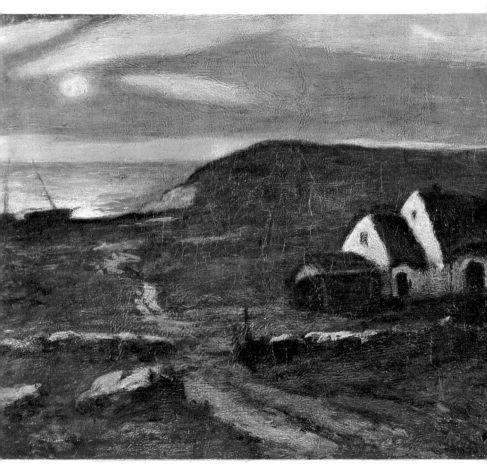

28 *Albert Pinkham Ryder (1847–1917) : Fishermen's huts. Washington,*
Phillips Collection.

28 Albert Pinkham Ryder (1847–1917): *Fishermen's huts*. Washington, Phillips Collection.
The memory of the sea which Ryder carried with him from his native countryside suggested mystical visions of nature which artistically are the equal of his scenes inspired by Shakespeare and Wagner.

29 John Singer Sargent (1856–1925): *Portrait of Mrs X*. 1884. New York, Metropolitan Museum of Art.
John Sargent's pictures generally have the sparkling immediacy of a gesture or a smile, but they also possess a light, superficial (though not unpleasing) quality, as though the visual expression has been achieved at the expense of a true spiritual interpretation.

30 John Singer Sargent (1856–1925): *Lunch on the loggia*. Washington, Freer Gallery.
'I do not pass judgment,' Sargent said of himself, 'I simply record.' In his painting it is indeed possible to discover all the virtues and defects inherent in an attempt to record one's age.

31 John Twachman (1853–1902): *Reflections*. New York, Brooklyn Museum.
There is an echo of the great Impressionist paintings in this picture, though its execution is somewhat ingenuous.

32 Childe Hassam (1859–1935): *Bailey's Beach, Newport*. 1901. Chicago, The Art Institute.
Hassam fell under the influence of Monet, which spurred him to a fresher, more natural style of landscape painting.

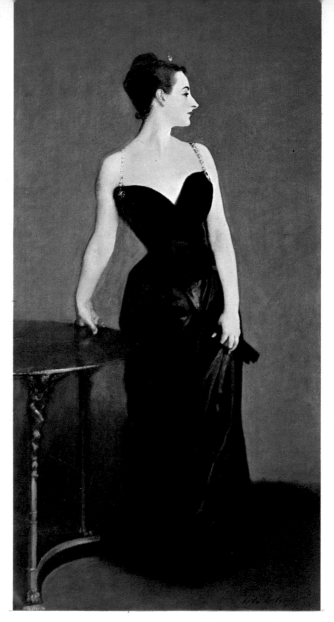

29 *John Singer Sargent (1856–1925) : Portrait of Mrs X.
1884. New York, Metropolitan Museum of Art.*

T019629

30 *John Singer Sargent (1856–1925)*: *Lunch on the loggia. Washington, Freer Gallery.*

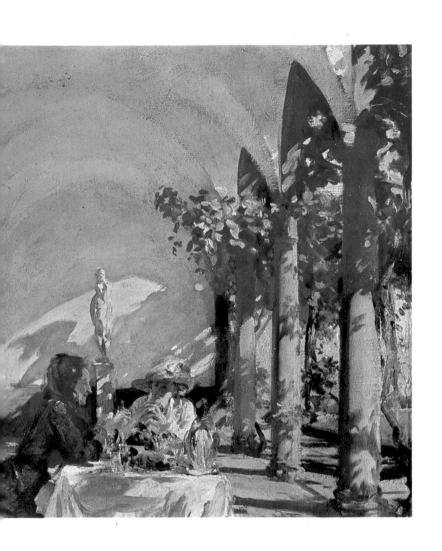

31 *John Twachman (1853–1902) : Reflections. New York, Brooklyn Museum.*

32 *Childe Hassam (1859–1935) : Bailey's Beach, Newport. 1901.
Chicago, the Art Institute.*

of elegant refinement; but there is always something superficial about his work, delightful though it may be on the surface.

In the last decades of the century there appeared a number of more enterprising painters like Theodore Robinson, Childe Hassam, Willard Leroy Metcalf, John Twachman and a few others, whose knowledge of Impressionism stimulated them to make new discoveries. The paintings of this group – though the use of the Impressionist technique is often crude and uncertain – are redeemed by the utter genuineness of their inspiration and the freshness with which the artist conveys the feelings aroused in him by the landscape. We should not forget that James Whistler, a lively and knowledgeable painter who had been brought up in France in the pre-Impressionist period, was also an American, if only by birth.

The main features of nineteenth-century American furniture are its simplicity, solidity and practicality, but it lacks those artistic qualities that only a tradition of skilled craftsmanship can make possible. Consequently, although European styles were popular, they were always interpreted by the local craftsmen with a certain crudeness. The same is generally true of pottery and the other decorative arts, where little work of interest was produced. It was only towards the end of the century, when American culture began to develop hand in hand with her industry, that definite changes gradually took place in this field of artistic creation. Furniture began to be designed in a comfortable, up-to-date manner; rocking-chairs were made and Louis Comfort Tiffany, a great artist working with glass, brought Art Nouveau, with its delight in sinuous, delicate shapes, to the attention of the American

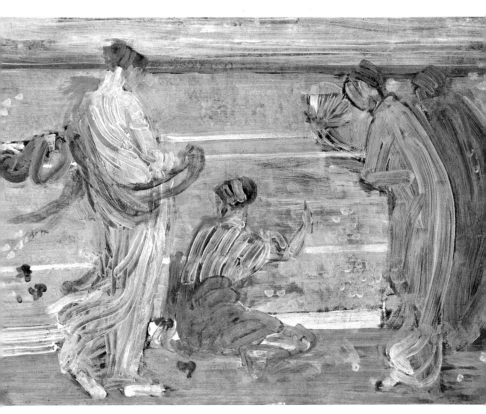

33 *James Abbott McNeill Whistler (1834–1903) : Fantasy in blue and green. Washington, Freer Gallery.*

33 James Abbott McNeill Whistler (1834–1903): *Fantasy in blue and green*. Washington, Freer Gallery.
The graceful attitudes of the women merely provide the artist with an excuse to study the secrets of colour-harmonies.

34 Willard Leroy Metcalf (1858–1925): *October morning*. 1917. Washington, Freer Gallery.
A pupil of the École de Paris, Metcalf was deeply influenced by Impressionism, though his precise draughtsmanship hardly suits his vivid, quivering light effects.

35 Winslow Homer (1830–1910): *Croquet*. 1866. Chicago, The Art Institute.
Homer's best work is to be found in these scenes of everyday life, rather than in his pictures of seascapes and battles, which suffer from an exaggerated emphasis on simply reproducing reality, whether they are sketches or oil-paintings.

36 William Merritt Chase (1849–1916): *Hide and seek*. 1888. Washington, Phillips Collection.
The boldness of the composition combined with the subtlety of the colours lead one to suspect Whistler's influence.

37 Louis Comfort Tiffany (1848–1933): *Vase*, made of glass. *c.* 1900. New York, Museum of Modern Art.
By varying the chemical composition of the glass, Tiffany achieved magnificent effects, from both a technical and an aesthetic point of view.

38 Louis Comfort Tiffany (1848–1933): *Vase with climbing leaves*. 1905. Darmstadt, Hessisches Landesmuseum.
Tiffany created forms which are influenced by Oriental Art but are also inspired by the demands of a completely modern sensibility.

39 Louis Comfort Tiffany (1848–1933): *Vase*, made of glass. *c.* 1900. New York, Museum of Modern Art.
This simple and elegant vase looks like a flower whose petals are about to unfurl.

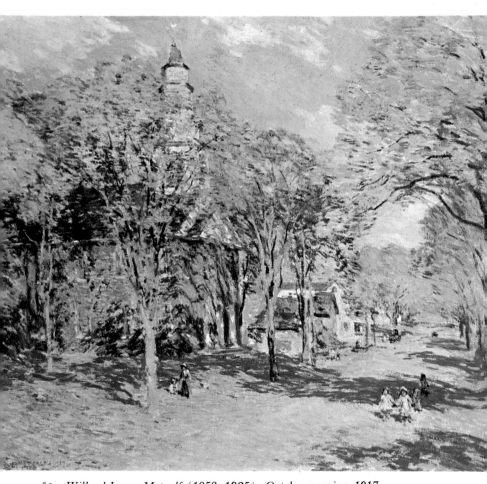

34 *Willard Leroy Metcalf (1858–1925) : October morning. 1917.*
Washington, Freer Gallery.

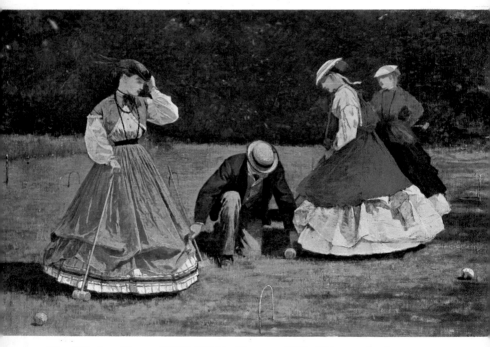

35 *Winslow Homer (1830–1910) : Croquet, 1866. Chicago, the Art Institute.*

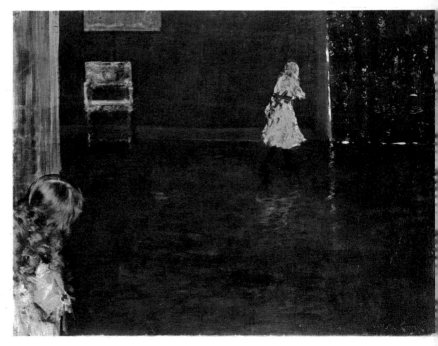

36 *William Merritt Chase (1849–1916) : Hide and seek. 1888.*
Washington, Phillips Collection.

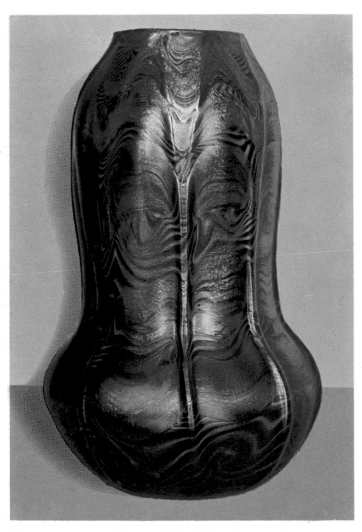

37 *Louis Comfort Tiffany (1848–1933) : Vase, made of glass. c.*
1900. New York, Museum of Modern Art.

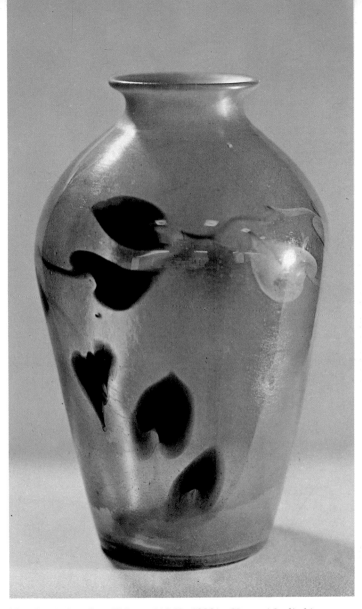

38 *Louis Comfort Tiffany (1848–1933) : Vase with climbing leaves. 1905. Darmstadt, Hessisches Landesmuseum.*

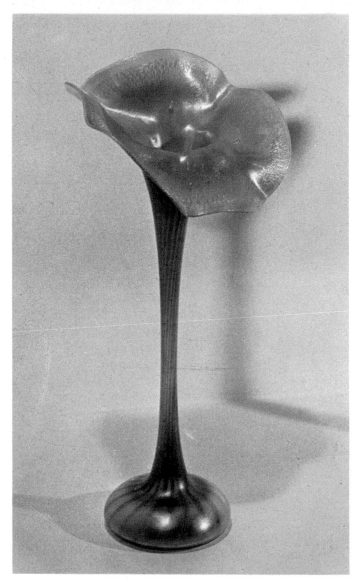

39 *Louis Comfort Tiffany (1848–1933) : Vase, made of glass. c. 1900. New York, Museum of Modern Art.*

public. His great originality consisted in an ability to obtain exquisite variations of colour without recourse to painted decoration, simply by using chemical methods to alter the glass itself.

THE TWENTIETH CENTURY: THE UNITED STATES AND EUROPE

Architecture

New economic and social needs (resulting largely from rapid industrial expansion), combined with those unprecedented technical possibilities that make modern architecture so original and exciting, have had an even greater effect in America than in Europe. Such a tendency is encouraged by the fact that the architects of this young nation are unhampered by any feelings of respect for old urban buildings and are free to carry out their town-planning schemes with reference only to the new requirements of the industrial age.

These requirements are fully satisfied by the skyscraper, which first appeared in the major cities, New York, Chicago and Philadelphia, in the second decade of the century. Their construction called for massive quantities of steel and glass and it is in fact the use of glass which is the most characteristic feature of modern American architecture. The skyscraper met certain obvious social needs: it facilitated the grouping of offices in the town-centres and it made full use of the limited space available, a problem that was aggravated by the large-scale migration of labour to the towns, itself a typical feature of increasing industrialization. The skyscraper is a direct descendant of certain buildings of the Chicago School, some of whose

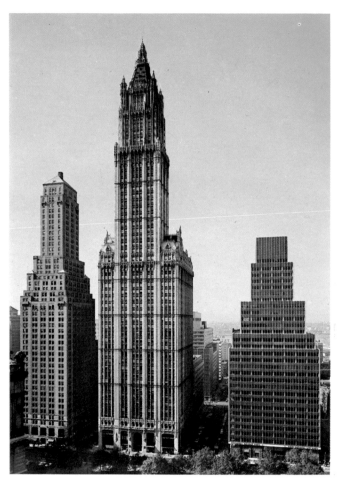

40 *Cass Gilbert (1859–1934) : Woolworth Building in New York. Finished in 1913.*

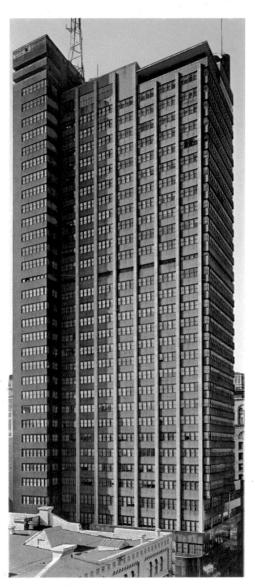

41 *George Howe (1886–1954), William
Lescaze (born in 1896) : Savings Fund
Society Building in Philadelphia, 1932.*

40 Cass Gilbert (1859–1934): *Woolworth Building* in New York. Finished in 1913.
Although the Woolworth Building was the first of a large number of skyscrapers, it remains the most striking example of the use of medieval forms in modern architecture.

41 George Howe (1886–1954), William Lescaze (born in 1896): *Savings Fund Society Building* in Philadelphia. 1932.
George Howe and William Lescaze collaborated on many buildings, applying their rational ideas with unflinching rigour.

42 Shreve, Lamb and Harmon: *Empire State Building* in New York. 1930–2.
Technical progress made it possible to construct immensely high buildings, like the Empire State Building, which is over 1,250 feet high.

43–44 Frank Lloyd Wright (1869–1959): *Hickox House* at Kankakee (Illinois). 1900. *Willitts House* at Highland Park (Illinois). 1902.
'. . . The architect's control over the design seems to be diminished or reduced to a temporary curiosity about ingenious, experimental ideas, in which he sometimes makes an unhesitating use of traditional, stylistic features.' (Benevolo).

45 Frank Lloyd Wright (1869–1959): *Robie House* in Chicago, 1909.
Wright's great quality was his versatility, his ability to adapt himself to widely different circumstances. Thus the functional rationality of his industrial buildings contrasts strongly with the harmonious variety of his small private houses.

46 Frank Lloyd Wright (1869–1959): *Hollyhoch House* in Los Angeles. 1920.
Wright's influence on the modern movement was of critical importance, as he succeeded, fairly early in his career, in developing with considerable freedom the formal qualities so typical of his work.

42 *Shreve, Lamb and Harmon : Empire State Building in New York, 1930–32.*

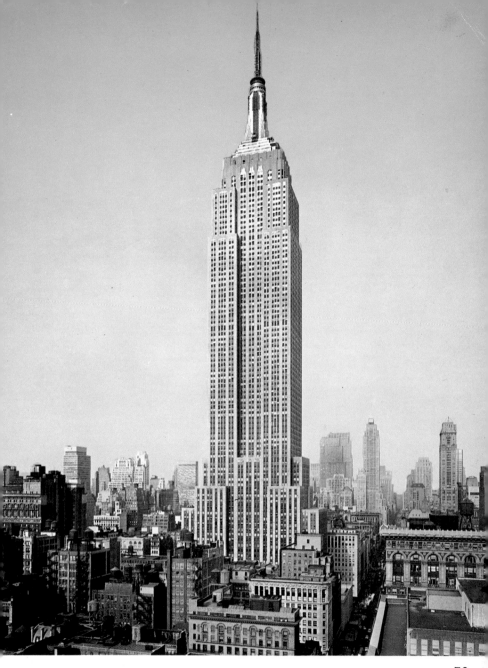

73

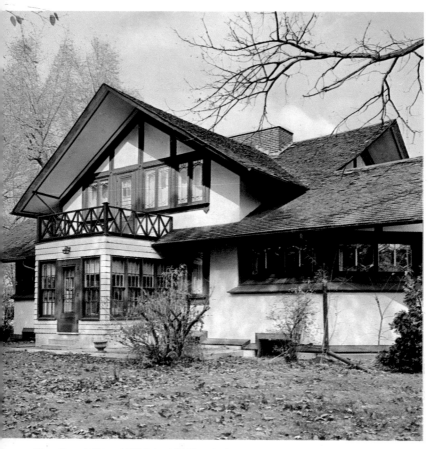

43 *Frank Lloyd Wright (1869–1959) : Hickox House at Kankakee (Illinois), 1900.*

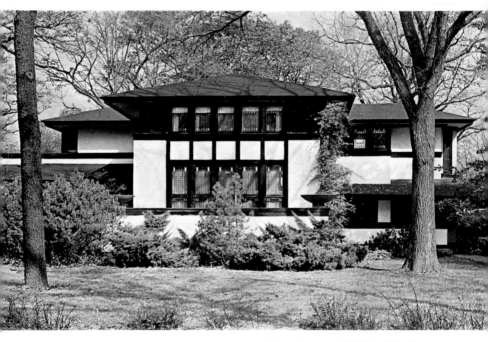

44 *Frank Lloyd Wright (1869–1959) : Willitts House at Highland Park (Illinois)*, *1902.*

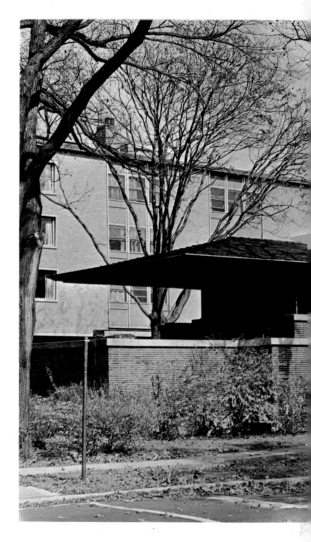

45 *Frank Lloyd Wright (1869–1959): Robie House in Chicago, 1909.*

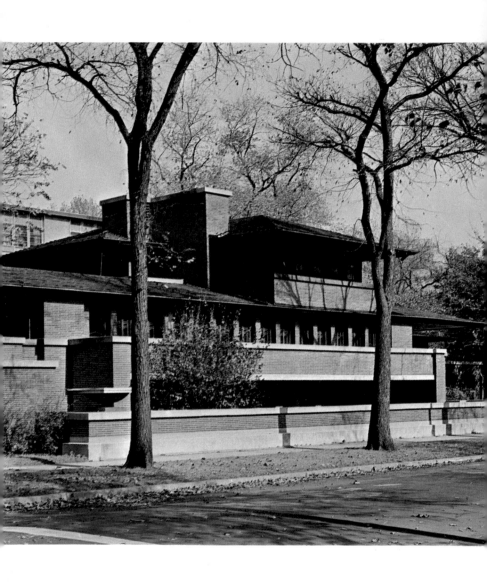

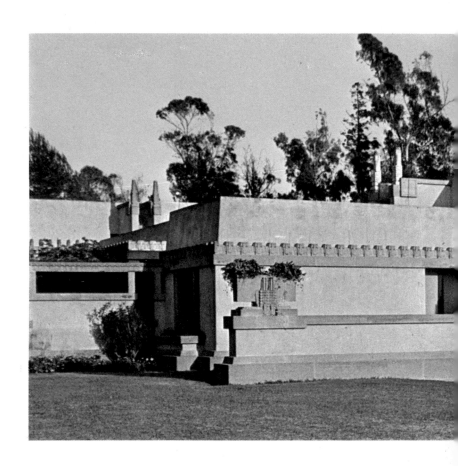

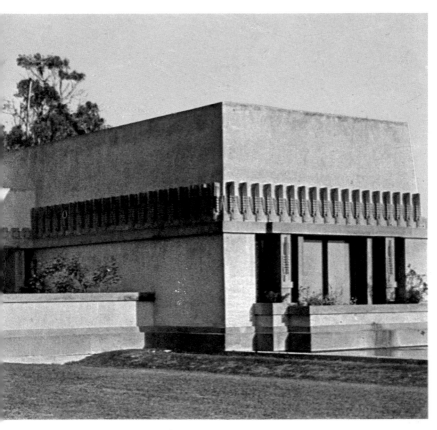

46 *Frank Lloyd Wright (1869–1959) : Hollyhoch House*
in Los Angeles, 1920.

representatives had already considered the possibility of 'high' buildings towards the end of the nineteenth century. Sullivan himself had already recommended an increased number of storeys and the abandonment of external differentiation.

The same problems were tackled in the twentieth century, though on a much larger scale. The buildings became higher and higher. The Empire State Building, for instance, long the highest skyscraper in New York (prior to the erection of the new World Trade Building), reaching a height of more than 1,250 feet, is a marvellous piece of engineering, just as the Eiffel Tower had been in its time.

Frank Lloyd Wright's work stands in striking contrast to the very grandeur of the skyscraper. A pupil of Sullivan's, Wright was more concerned with the individual problems inherent in the designing of private houses. He realized the need to blend the home with its surroundings, to abandon the idea of a house and its rooms as simply a collection of boxes, to plan the setting so that the atmosphere, the light and the view all combine with the building to give a total impression of unity. He had already put these basic ideas into practice when, as a young man in the first decade of the century, he had designed a group of single-family houses.

While the greatest European architects were fundamentally committed to adapting architecture to their society and its needs, Wright was mainly concerned that his buildings should blend with their natural environment. For Wright, a piece of architecture had no value in its own right, because its beauty derived from the extent to which it harmonized with its surroundings and combined with

nature to create a unity. This was no romantic escapism, arising from a refusal to face the modern world; on the contrary, it implied a different conception of man's nature and function, an individual in a society composed of individuals and not simply a cog in the wheel. A house is a place where a man lives, not just where he sleeps, and, in order to live, a man must have a sense of privacy and a feeling that nature is alive around him and he must derive from the solidity of his home a sense of security and comfort. For this reason Wright used any modern materials whose architectural or structural potential would enable him to achieve his clear stylistic and personal ideals. Moreover (and this is further evidence of his unswerving modernity) Wright never forgot that function precedes form and he thus avoided lapsing into sterile, purely decorative, styles of architecture.

It is not surprising, then, that Japanese architecture, with its well-defined structures and its appreciation of beautiful, natural surroundings, had a considerable effect on Wright. It helped him, above all, to strike that balance between practical and personal requirements, which is a permanent feature of his work.

At the beginning of the century, while European architecture was struggling with the effects of Art Nouveau, Wright aroused considerable interest among the future leaders of the modern school both for his stress on function and simplicity, and for his use of new materials. While in his early work, which shows a combination of Japanese and traditional American ideas, he achieved a sense of unity between the building and its natural surroundings, he was later influenced by European innovations to undertake more complex buildings such as the Kaufmann House on

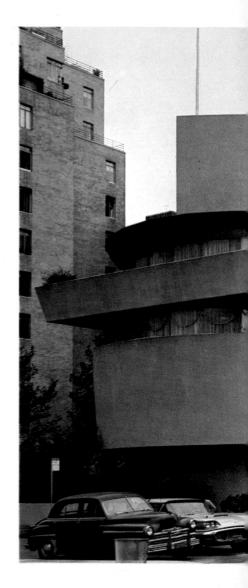

47 *Frank Lloyd
Wright
(1869–1959) :
Solomon R.
Guggenheim
Museum in New
York, 1946–60.*

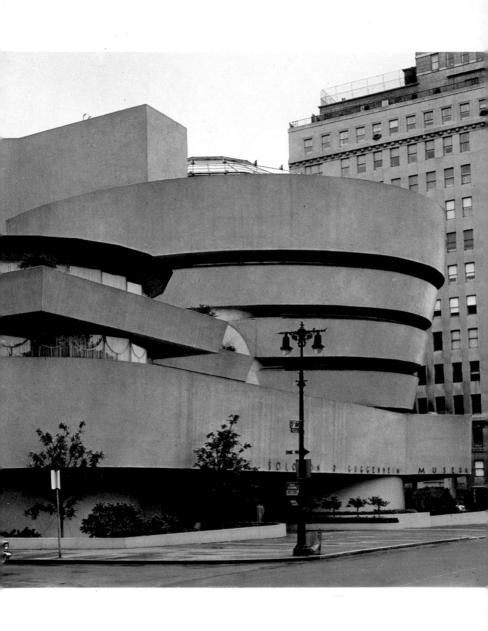

47 Frank Lloyd Wright (1869–1959): *Solomon R. Guggenheim Museum* in New York. 1946–60.
The Solomon R. Guggenheim Museum, though planned in 1946, was not completed until 1960, after the architect's death. It was a worthy epilogue to a lifetime's work.

48 Frank Lloyd Wright (1869–1959): *Johnson Office Works* at Racine (Wisconsin) 1936/9–1946/9.
The Johnson Office Works, the Kaufmann House, the school of Taliesin West, Arizona, and other buildings of this period demonstrate Wright's desire to blend European and purely American styles of architecture.

49 Ludwig Mies van der Rohe (born 1886): *Skyscrapers* in Chicago. 1949–51.
Van der Rohe's originality consists mainly in his mathematical strictness, his technique being to take the rectangular window as his fundamental building unit, against which the spatial relations of the whole are measured.

50 Ludwig Mies van der Rohe (born 1886): *Seagram Building* in New York. 1956.
'In its simplest form, architecture depends on functional considerations, but it can achieve a spiritual quality in varying degrees and ultimately attain the highest spheres of spiritual accomplishment, the realm of pure art.' (Mies van der Rohe).

51 Richard Neutra (born 1892): *Villa* in Los Angeles.
Although he kept abreast of his contemporaries' most up-to-date ideas, Richard Neutra's architecture has a formal, almost conventional severity, remaining sober and restrained. His work has enjoyed enormous popularity among Hollywood actors.

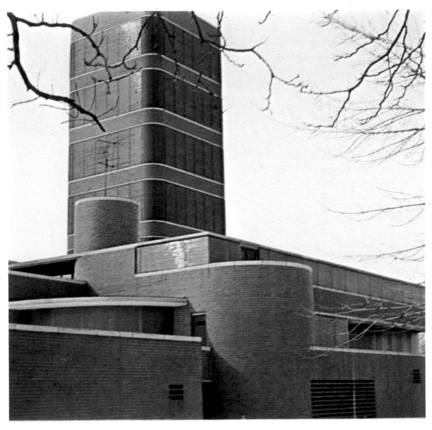

48 *Frank Lloyd Wright (1869–1959)* : *Johnson Office Works at Racine
(Wisconsin) 1936/9–1946/9.*

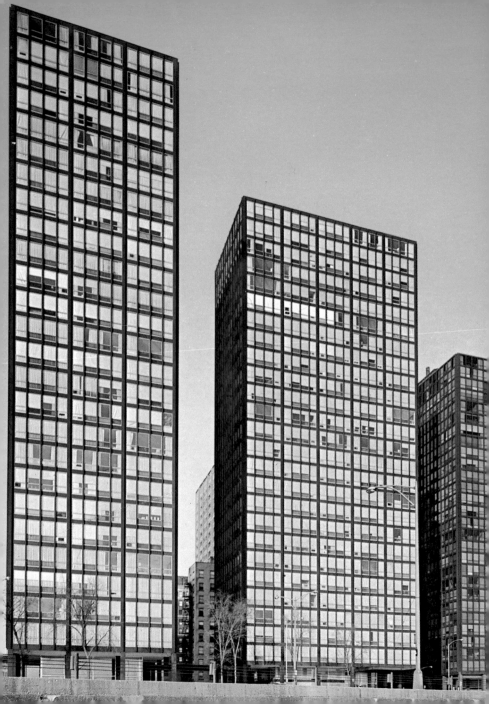

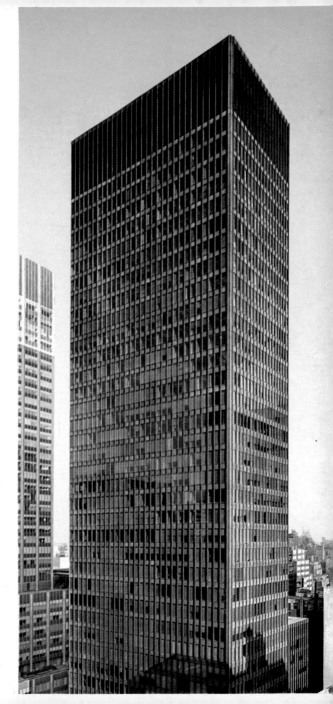

49 *Ludwig*
Mies van der
Rohe (born in
1886):
skyscrapers in
Chicago.
1949–51.

50 *Ludwig*
Mies van der
Rohe (born in
1886):
Seagram
Building in New
York, 1956.

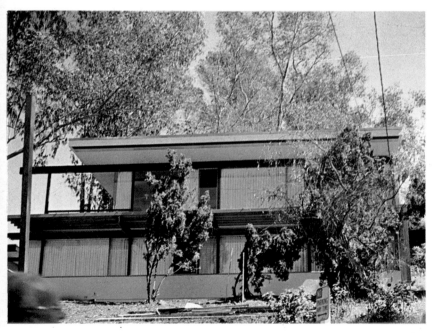

51 *Richard Neutra (born in 1892) : Villa in Los Angeles*

the waterfall and the Johnson Office Works. These were splendid achievements which he was never to equal during the later part of his active life, when he became excessively concerned with purely intellectual problems of design. The successive stages of his career, however, form a completely logical and coherent pattern, from the prairie houses of his early days to the upside-down cone which forms the central element of the Solomon R. Guggenheim Museum in New York.

In the thirties the United States became a focal point for many European artists who began to settle there in ever-increasing numbers, drawn by the enormous opportunities offered by this fast-expanding society. Some emigrated to America for political reasons, including a number of anti-Nazi German artists and intellectuals, from Gropius and other important members of the Bauhaus School to Thomas Mann, Panofsky, Auerbach etc. During this period, Europe, and Germany in particular, had a great influence on every branch of American cultural development.

Richard Neutra did the majority of his work in America. Although he was one of Loos's pupils, he soon asserted his own personal ideas. In his work, the technical side of building and the treatment of detail are more significant than purely formal invention; there is no sense of aridity, however, simply an understanding of the requirements of the whole and a deep respect for the materials used. He fully appreciated, moreover, the importance of the relationship between the building and its surroundings, but he was not concerned, like Lloyd Wright, with achieving a poetic unity between these two elements; on the contrary, he used the surroundings to emphasize the man-made

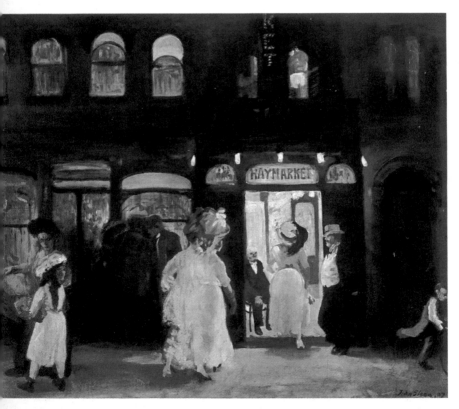

52 *John Sloan (1871–?) : Haymarket. 1907. New York, Brooklyn Museum.*

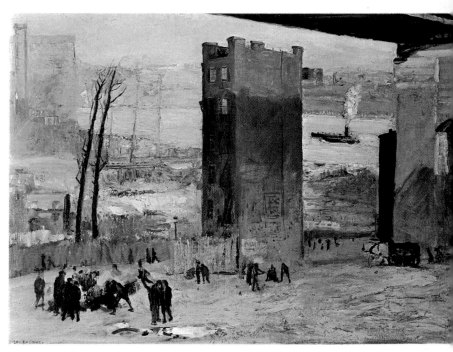

53 *George Bellows (1882–1924) : The lone tenement. Washington, National Gallery of Art.*

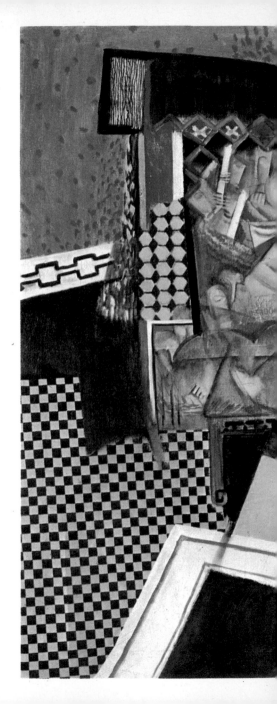

54 *Max Weber
(born in 1881):
Chinese restaurant.
1915. New York,
Whitney Museum
of American Art.*

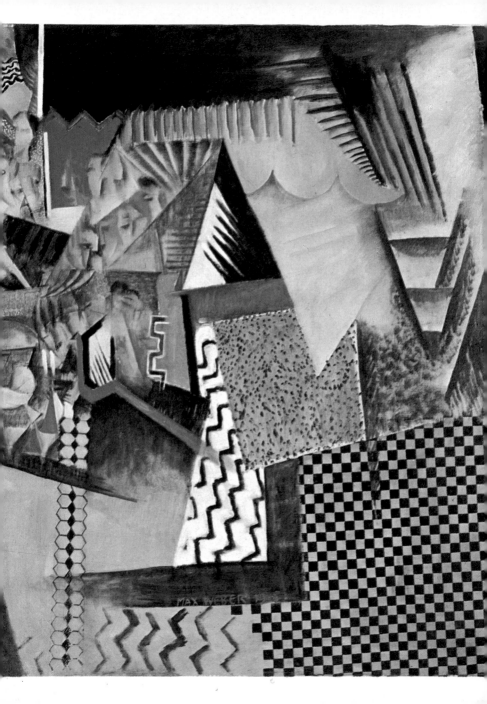

55 *Charles Demuth (1883–1935) : Objects. 1921. Chicago, the Art Institute.*

52 John Sloan (1871– ?): *Haymarket*. 1907. New York, Brooklyn Museum.
The life of the big cities, with all its activity, variety of interest and vast range, has frequently provided American artists with a source of inspiration. This is the case with Sloan, whose love for New York is combined with a profound but sometimes bitterly ironical interest in its inhabitants.

53 George Bellows (1882–1924): *The lone tenement*. Washington, National Gallery of Art.
In George Bellows's early work the influence of Impressionism is combined with the inner feeling of the Nabis to produce paintings of outstanding, lyrical freshness.

54 Max Weber (born 1881): *Chinese restaurant*. 1915. New York, Whitney Museum of American Art.
The agitated rhythm of this work is due to the Cubist concept of breaking up the composition into a series of images. The two areas filled with little black and yellow squares perform the same function as the early Cubist collages.

55 Charles Demuth (1883–1935): *Objects*. 1921. Chicago, The Art Institute. Alfred Stieglitz Collection.
After studying in Pennsylvania Charles Demuth went to Paris, where he came into contact with the Cubism of Metzinger and Gleizes and also with the mechanical forms of Fernand Léger.

56 Joseph Stella (1879–1946): *Brooklyn Bridge*. 1939. New York. Whitney Museum of American Art.
The glorification of the notion of progress, so much a part of American civilization, is represented in this poetic interpretation of Brooklyn Bridge.

57 John Marin (1870–1953): *Quoddy Head, Maine Coast*. 1933. Washington, Phillips Collection.
After living in Paris for several years, John Marin fell deeply under the influence of Cubism and Fauvism; but in his best work he succeeded in developing from these ideas a very individual style.

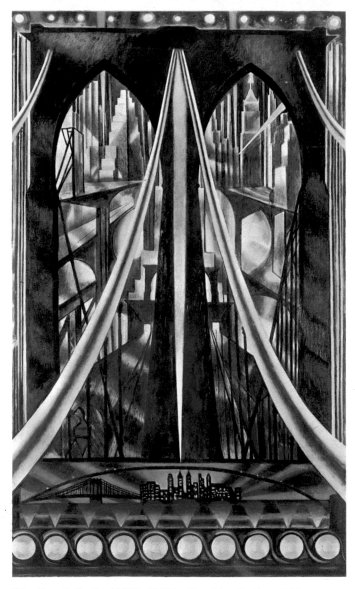

56 *Joseph Stella (1879–1946) : Brooklyn Bridge. 1939. New York, Whitney Museum of American Art.*

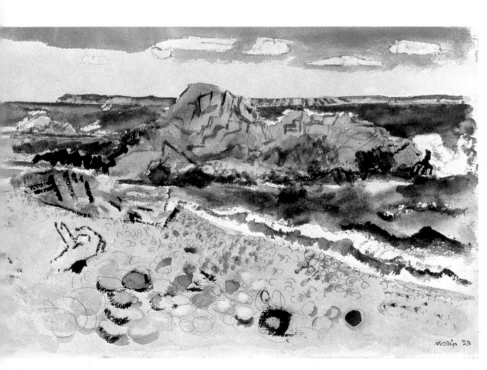

57 *John Marin (1870–1953) : Quoddy Head, Maine Coast, 1933.*
Washington, Phillips Collection.

structures, to make them stand out more imposingly. Ludwig Mies van der Rohe was a more enterprising architect who was closely involved in the development of the modern movement. Not only did he make important theoretical contributions to the subject, but he anticipated many modern architectural trends and developments.

After studying under Behrens, Berlage and other masters, he became, in the immediate postwar period, one of the first to demonstrate the immense potential of reinforced concrete, steel and glass, though his plans remained purely theoretical. He showed how the inner power of a building is increased by minimizing the external covering and stressed that an organic unity should replace the traditional internal-external duality, as occurs in Corbusier's work, and that space should be harmoniously articulated with a classical purity of line and proportion.

These characteristics of Mies van der Rohe's work are to be seen not only in his early European designs but to an even greater extent in the superb skyscrapers which he designed in America after emigrating there in 1937. Now he was able to realize the ideas that he had formulated on paper twenty years earlier and it is an extraordinary fact that they had lost nothing of their modernity or essentially classical vigour.

Painting

Europe's profoundest influence on the development and orientation of American art was in the field of painting. At the beginning of the twentieth century, the most important factor in American painting was the survival of an essentially post-Impressionist tradition of European origin, into which, however, American themes and ideas

were beginning to filter. The language used was that of post-Impressionism, with occasional traces of Realism, but now new, original subjects were tackled, which drew their inspiration from the observation of American society and the American way of life. Prendergast, Sloan, Glackens and Bellows were the most typical painters of this school, which was soon to be shaken by the latest innovations of European art.

After the Matisse exhibition in 1908 and the Picasso exhibition of 1911, a large exhibition, known as the Armory Show, was organized in 1913 and it was here that the American public became aware for the first time of the vast range of recent European art, from Picasso, Braque and Derain to Brancusi and Kandinsky. Next to the work of these great masters could be seen the pictures of young American artists who had absorbed the new ideas while living in Paris and other European cultural centres. It was in this way that America discovered Cubism and Futurism, two movements that were to have the greatest effect on American painting. The search for dynamic effect, a characteristic of both the Section d'Or and of Futurism, particularly attracted American artists because they recognized a link between that and the realities of indust-rial civilization, of that rapid and frantic urban develop-ment of which Americans were so acutely aware at the beginning of the century.

This absorption of European artistic ideas can best be seen in the work of Max Weber, who fell mainly under the influence of Cubism, Joseph Stella, who had been taught on Futurist principles, and a group of synchromists (the American equivalent of the French Orphists). These ideas were employed, however, to interpret the new

58 *Man Ray (born in 1890) : A night at Saint Jean-de-Luz. 1929. Paris, National Modern Art Museum.*

58 Man Ray (born 1890): *A night at Saint Jean-de-Luz*. 1929. Paris, National Modern Art Museum.
After studying in New York Man Ray moved to Paris, where he worked first with the Dadaists, later with the Surrealists.

59 Man Ray (born 1890): *The misunderstood*. 1938. Paris, the artist's collection.
Although Man Ray is well-known for his painting, he primarily devoted himself to photography and the *cinema dell'arte*.

60 Charles Sheeler (born 1883): *The main deck*. Cambridge (Massachusetts), by permission of the Fogg Art Museum. Harvard University. Luise E. Bettens Fund.
According to F. S. Wight, Sheeler 'introduced to the world the American way of seeing things'. We find in his paintings the rational precision that is so typical of the technological civilization of North America.

61 Niles Spencer (1893–1952): *City walls*. 1921. New York, Museum of Modern Art.
Niles Spencer, one of the Immaculates group, wanted to return to representational art without abandoning a certain degree of abstraction in his design.

62 Charles Burchfield (born 1893): *The house of mystery*. Chicago, The Art Institute.
'I have attempted to recreate certain states of mind, like fear of the dark, the smell of flowers before a storm, and even to convey various sounds, like the noise of insects.' (Burchfield).

63 Edward Hopper (born 1882): *House on the river Pamet*. New York, Whitney Museum of American Art.
The American Realist tradition is modified by a certain European romanticism to produce these melancholy landscapes by Edward Hopper, which are full of a quiet melancholy.

64 Edward Hopper (born 1882): *Night-wanderers*. 1942. Chicago, The Art Institute.
In this picture the coldness of the immense window and the yellow light seem to give the bar a new dimension.

59 *Man Ray (born in 1890) : The misunderstood. 1938. Paris, the artist's collection.*

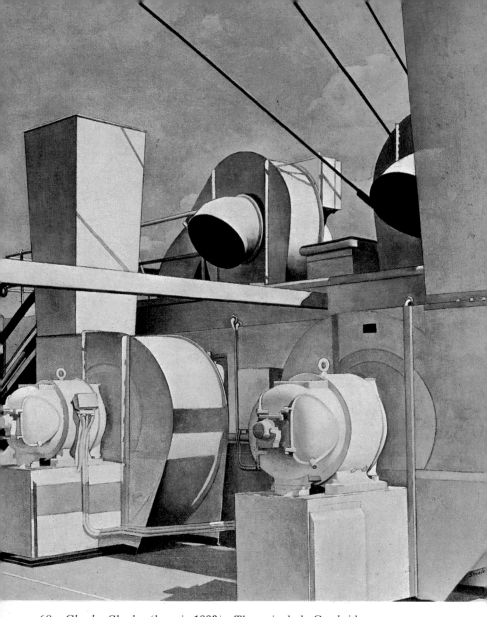

60 *Charles Sheeler (born in 1883) : The main deck. Cambridge (Massachusetts), by permission of the Fogg Art Museum, Harvard University.*

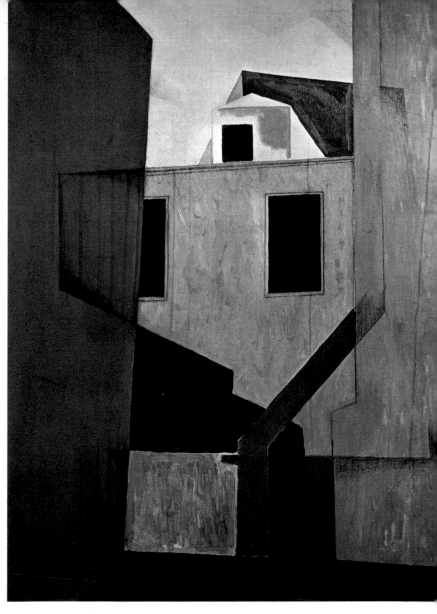

61 *Niles Spencer (1893–1952) : City walls. 1921. New York, Museum of Modern Art.*

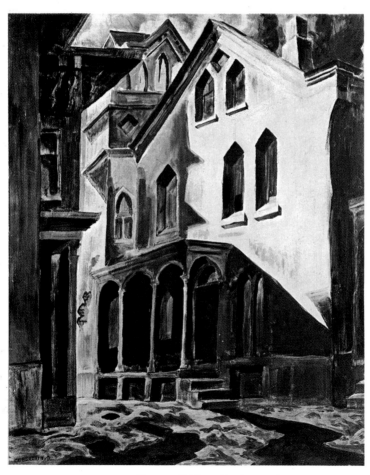

62 *Charles Burchfield (born in 1893) : The house of mystery.
Chicago, the Art Institute.*

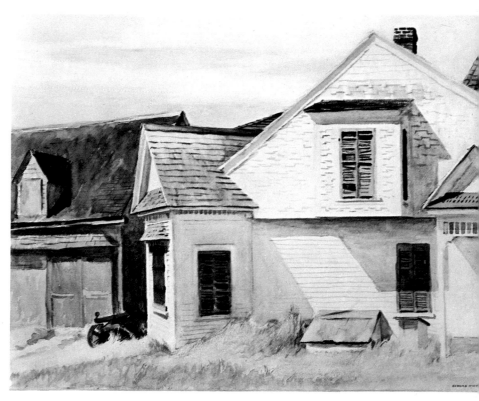

63 *Edward Hopper (born in 1882) : House on the river Pamet. New York, Whitney Museum of American Art.*

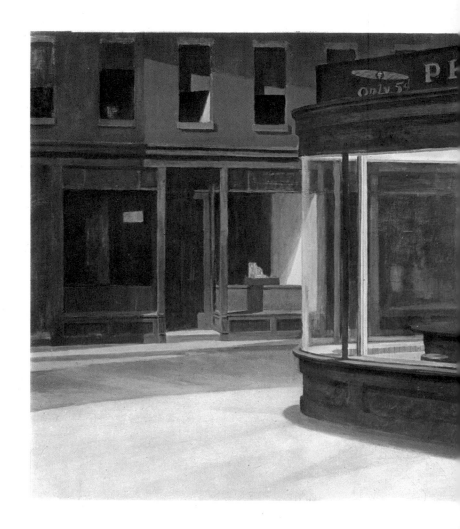

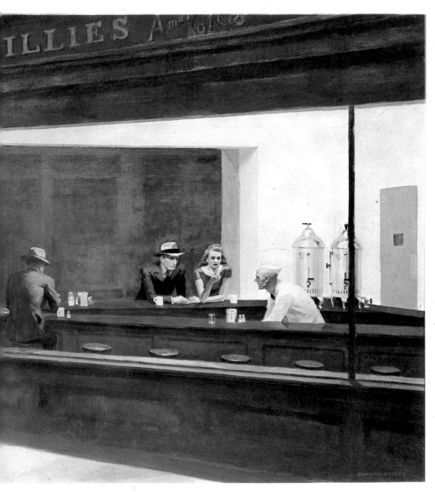

64 *Edward Hopper (born in 1882) : Night-wanderers. 1942. Chicago,*
the Art Institute.

American culture in a vivid and dynamic manner. The influence of Cubism can also be observed in the elegant work of Charles Demuth, who later made some almost Dadaist experiments, and in that of John Marin. Marin resembles Feininger in many respects, especially in the menacing, sometimes darkly tragic atmosphere of his landscapes, which are composed according to principles reminiscent, on the one hand, of Kandinsky's work and, on the other, that of the Section d'Or and Delaunay.

The Dada movement was introduced into America by Marcel Duchamp and Picabia. These two French artists, supported by Arthur Cravan and Man Ray, put on shows and issued publications that were typically Dadaist. Duchamp exhibited his wares, simple everyday factory-made objects, which he signed as his own work and to which he gave titles that completely altered their meaning. Cravan gave talks on painting in which he behaved in that provocative manner that is so typical of the Dada movement; he would arrive at the meeting completely drunk, strew dirty laundry on the table prepared for the talk, and end up by provoking the usual burst of public indignation, just as he had intended to do.

Ray was the most important American Dadaist and the creator of the famous 'X-rays of the real world', called 'rayographs' in his honour. He moved to Paris in 1925, where he joined the Surrealist movement. Picabia returned home in 1918, at the end of the war. Generally speaking, American Dadaism had had a rather short life, with a minimal effect on American art.

While European ideas were making themselves felt, a group known as the Immaculates was developing a more typically American school of art during the twenties. The

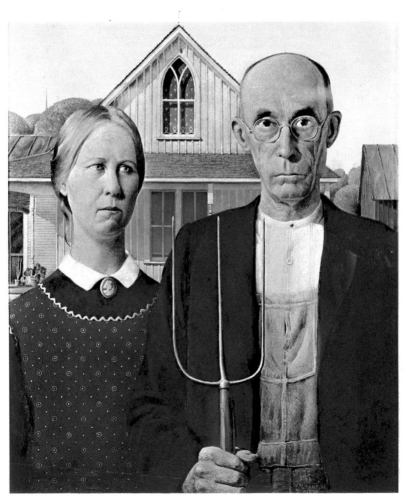

65 *Grant Wood (1891–1942): American gothic. 1930. Chicago, the Art Institute.*

65 Grant Wood (1891–1942): *American gothic*. 1930. Chicago, The Art Institute.
The stiff posture of the two figures, the bleak, austere dignity of their clothes and the icy composure of their carefully drawn faces are eloquently representative of a simple style of life, organized in accordance with Puritan principles of morality.

66 Ivan Le Lorraine Albright (born 1897): *Poor room*. 1942. Chicago, The Art Institute. Property of the artist.
The artist worked on this painting for more than fifteen years and provisionally gave it this very long title: Poor room – There is no time, neither end, nor today, nor yesterday, nor tomorrow, only eternity, eternity, eternity without end.

67 Jack Levine (born 1915): *Welcome home!* 1946. New York, Brooklyn Museum.
Jack Levine's biting wit uses strange light effects and brush-strokes of varying breadth to create an ironic effect, to produce satire which is deliberately contrived, though absolutely objective.

68 Philip Evergood (born 1901): *Still life*. 1944. New York, Collection of Mr Hudson D. Walker and Mrs Forest Hill.
Like Jack Levine, Philip Evergood joined the American Realist painters who made use of Expressionism to intensify their social protest.

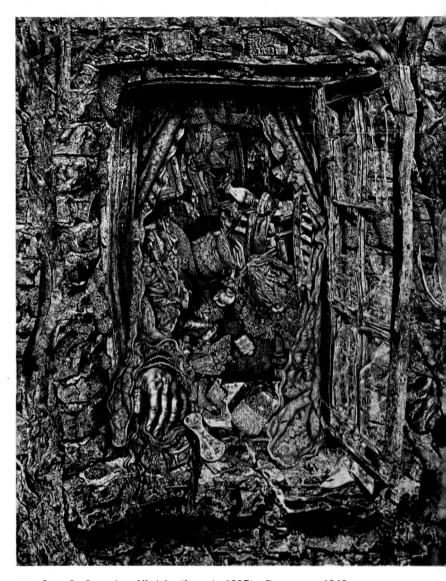

66 *Ivan Le Lorraine Albright (born in 1897) : Poor room. 1942.*
Chicago, the Art Institute.

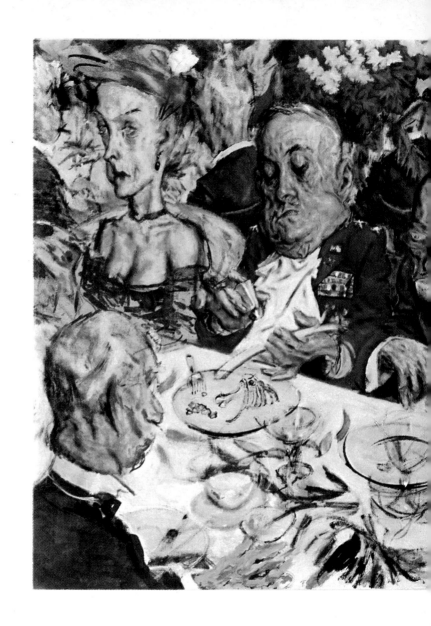

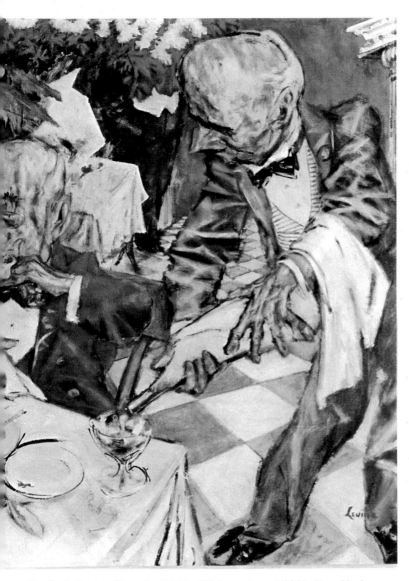

67　*Jack Levine (born in 1915) : Welcome home! 1946. New York,*
Brooklyn Museum.

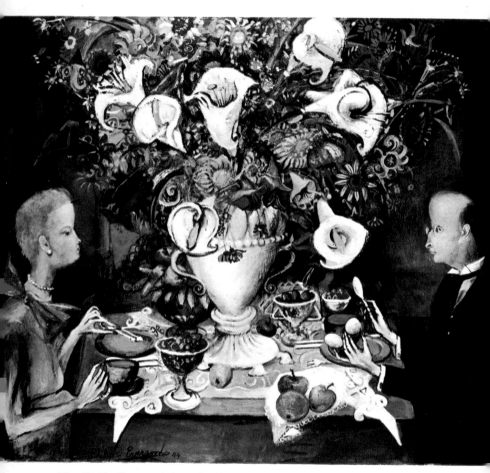

68 *Philip Evergood (born in 1901) : Still life. 1944. New York, Collection
of Mr Hudson D. Walker and Mrs Forest Hill.*

Immaculates, who included Sheeler, Spencer, Georgia O'Keeffe and (again) Demuth, laid stress on strict simplicity of representation, a kind of stylistic purity that almost reaches the limits of abstraction. Their subjects are inspired by the machine age – factories, ships, bridges, roads etc – and nothing superfluous enters into their representation, which is utterly precise and straightforward.

Edward Hopper, however, saw the American cities and countryside in a different light; though a realistic painter, his work has poetic qualities not unmixed with a certain deep melancholy. Whether he was painting scenes of city life, half-empty streets in the evening light, or domestic happenings, there is always a feeling of tranquillity, a vague sense of loneliness and uncertainty which expresses the atmosphere of the big cities where the small details of peoples' lives tend to get submerged and lose their meaning. Hopper's style has been defined as 'magical realism', for while he clearly represents things as they really are, they are unexpectedly transformed by the unreal air which surrounds them, and given a life of their own which one would never have thought possible.

Next to Hopper's poetic realism is the more violent, more locally biased realism of artists such as Grant Wood and John Kane, and the scrupulous detail of Charles Burchfield. Even into the forties the simple observation of reality lies at the core of all American painting, although the various trends give it greater or less emphasis. Even if it sometimes became an obsession, as in the almost grotesquely realistic work of Ivan Albright, it also gave rise to social realism, one of the most important American movements arising from the economic and social crises of 1929.

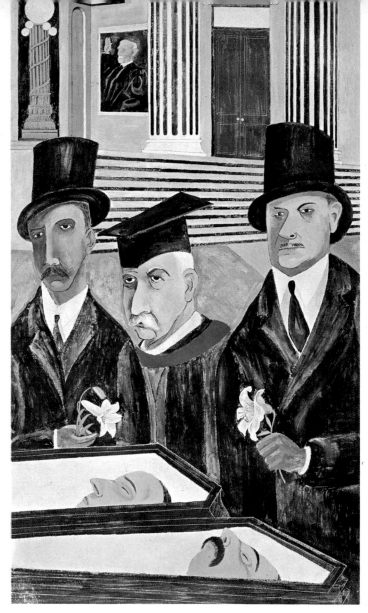

69 *Ben Shahn (born in 1898) : The passion of Sacco and Vanzetti (detail). 1931–2. New York, Whitney Museum of American Art.*

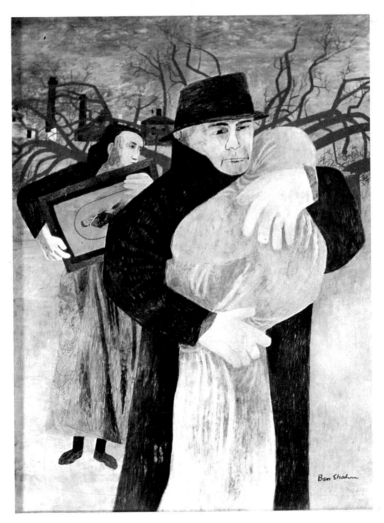

70 *Ben Shahn (born in 1898) : Father and son. 1946. New York, Museum of Modern Art.*

69 Ben Shahn (born 1898): *The passion of Sacco and Vanzetti* (detail). 1931–2. New York, Whitney Museum of American Art.
Ben Shahn's outstanding gifts as a draughtsman are typified by this painting, both in the exquisite play of lines on the coffins, which is continued and amplified in the steps and columns, and in the magnificent group of the three men, whose faces afford abundant evidence of Shahn's talent for shrewd social satire.

70 Ben Shahn (born 1898): *Father and son.* 1946. New York, Museum of Modern Art.
This painting displays the qualities which give such a deeply poetical effect to so much of Shahn's work: his ability to understand and share people's unexpressed feelings, and his warm affection for humanity.

71 Arthur Dove (1880–1946): *Flour mill abstraction.* 1938. Washington, Phillips Collection.
American artists tried out new art styles and experimented with avant-garde painting before returning to representational art, which meant, for them, returning to a true understanding of the American way of life.

72 Stuart Davis (born 1894): *Something on the 8-ball.* 1953–4. Philadelphia, Museum of Art.
Stuart Davis often uses advertisements and other items of mass-communication, as this represents 'a psychological identification with the outside world, including that area of general activity known as language'.

73 Stuart Davis (born 1894): *The Paris bit.* New York, Whitney Museum of American Art.
The exciting rhythm of the vivid, intertwining signs enables the artist to produce a composition based on a highly decorative graphic design.

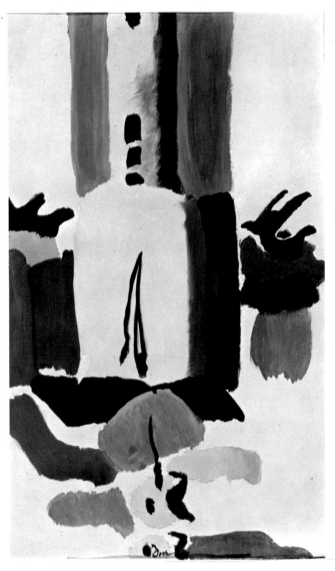

71 *Arthur Dove (1880–1946) : Flour mill abstraction.*
1938. Washington, Phillips Collection.

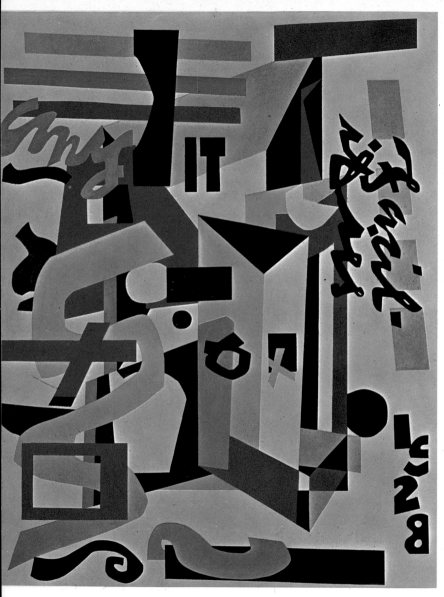

72 Stuart Davis (born in 1894) : Something on the 8-ball. 1953–4.
Philadelphia, Museum of Art.

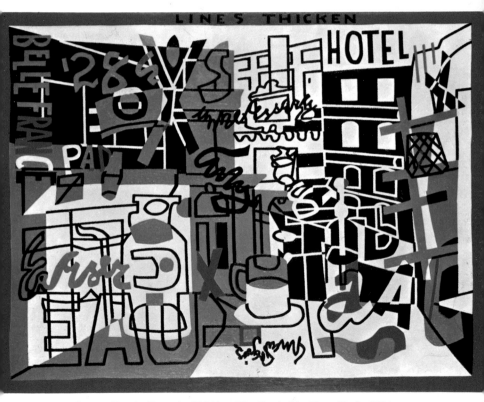

73 *Stuart Davis (born in 1894) : The Paris bit. New York, Whitney Museum of American Art.*

This movement contained many outstanding painters, ranging from Jack Levine's bitterly satirical attacks on the bourgeoisie to Evergood's and Gropper's violent social protest, and Ben Shahn's poignant awareness of the crisis that had overtaken the world. It is Shahn's personality that dominates all the others; a poet who spoke for the poor, the deprived and the exploited, as violent in his attacks on injustice and corruption as he was compassionate in his presentation of the innocent victims of a society that was breaking down. The most striking features of his work are the oppressive buildings, the grotesque shapes of his figures, his frozen, melancholy faces, his use of cold, sharp colours in strong contrast with one another. Shahn is one of the purest and greatest American painters of the century.

Apart from the Realists, the thirties also witnessed the experiments of some other painters who tried to combine a genuine American inspiration with ideas and techniques borrowed from European art. Peter Blume, for example, expressed his own visionary ideas in pictures reminiscent of Surrealism. Similarly Stuart Davis, who had been particularly struck by the recent work of Léger and the post-Cubists that he had seen in Paris, expressed the colour and noise of American cities in glaring compositions, using signs and cuttings, with a mixture of matching and clashing colours and lines. Again, Mark Tobey made use of an elegant, abstract kind of script (an idea which he picked up while living in the East), in order to express the exciting, dynamic nature of city night-life.

Although the opening years of the twentieth century saw American painting still dependent on a somewhat meagre artistic tradition, and that mostly derived from Europe,

by the beginning of the Second World War the situation had completely changed. Forty years had in fact been sufficient for American painters to develop their own distinctive artistic ideas and styles worthy of comparison with the most important European movements of the time. By this time American art already had the benefit of its own substantial tradition, and there were many brilliant painters of the highest calibre. To mention only a few, there was Ben Shahn and his expressive and poetical social realism; Edward Hopper with his profound, lyrical style; John Marin, brilliantly imaginative, striking a perfect balance between the abstract improvisation and the rational, structural composition of later Cubism; and many original contributors to abstract art, such as Mark Tobey and his calligraphic symbols, Stuart Davis, vivid and dynamic, and Morris Graves with his broad, deeply expressive brush-strokes.

Mark Tobey, a friend of Feininger, with whom he had collaborated on various artistic experiments and researches around the war years, was to play a pre-eminent part in the establishment of a new American movement in the field of abstract art. What he calls his 'white writing' is based on his studies of Chinese and Japanese painting and produces a vivid interpretation of the world and nature in terms of movement and pure light. Impressionist abstract art has learnt much from the tireless, dynamic energy of Tobey's twisting and twining lines.

The influence of European art is of course still evident in much of this activity, but American artists are no longer content simply to absorb, like it or not, the artistic experiments, research and achievements of European artists. After the thirties there were close contacts between

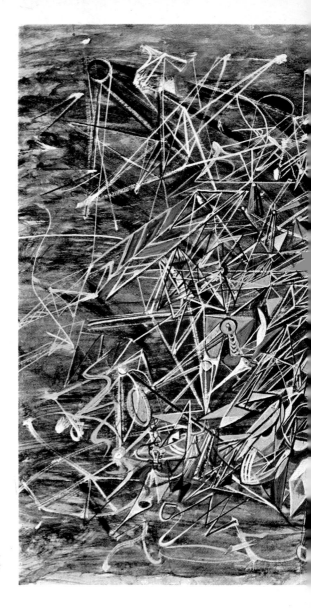

74　*Mark Tobey*
(born in 1890) :
Forms follow man.
1943. Seattle, Art
Museum.

126

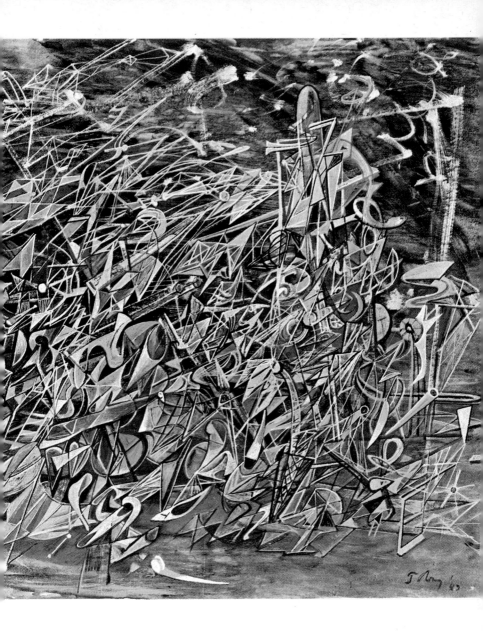

74 Mark Tobey (born 1890): *Forms follow man*. 1943. Seattle, Art Museum. Fuller Collection.

Tobey, who taught Morris Graves, is considered to be one of the greatest exponents of non-representational American Art.

75 Mark Tobey (born 1890): *Composition*. Milan, private collection.

The East made a great impression on Tobey and its influence is clear throughout his work. It is not that he imitated Oriental art, but rather that he felt a spiritual affinity with it.

76 Morris Graves (born 1910): *Flight of Birds*. 1955. New York, Whitney Museum of American Art.

Birds constitute one of the recurrent themes in Morris Graves's work. Sometimes they are dark, threatening shapes which have an uncertain, nightmarish quality; sometimes they are mysterious, ghostly forms; sometimes they swoop through the air.

77 Fernand Léger (1881–1955): *Two women with flowers*. 1946. Basle, Beyeler Gallery.

One of the new characteristics of this period is the random covering of compositions with strips of colour. By this method Léger intended to express the sudden changes of colour as reflected on people's faces by the twinkling lights of Broadway.

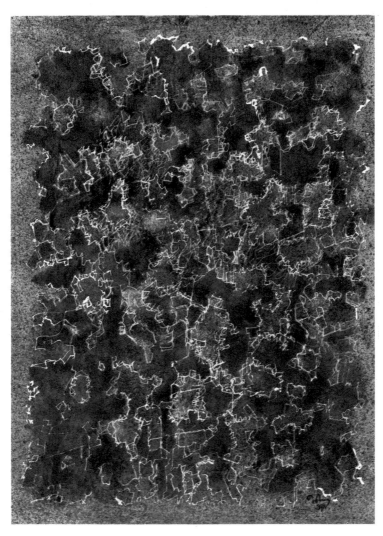

75 *Mark Tobey (born in 1890) : Composition. Milan, private
collection.*

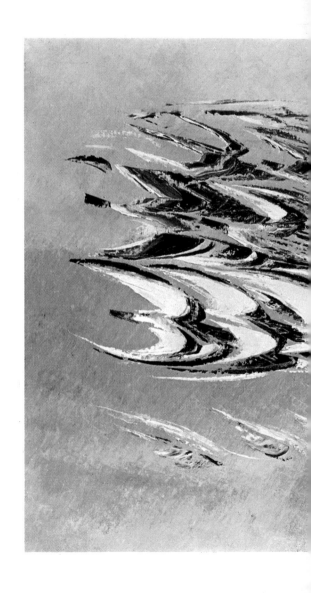

76 *Morris Graves (born in 1910) : Flight of birds. 1955. New York.*
Whitney Museum of American Art.

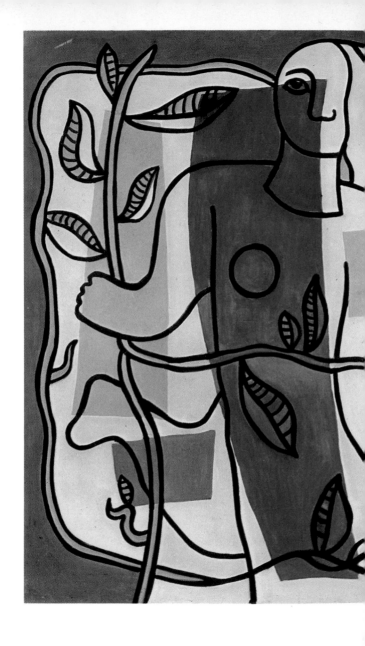

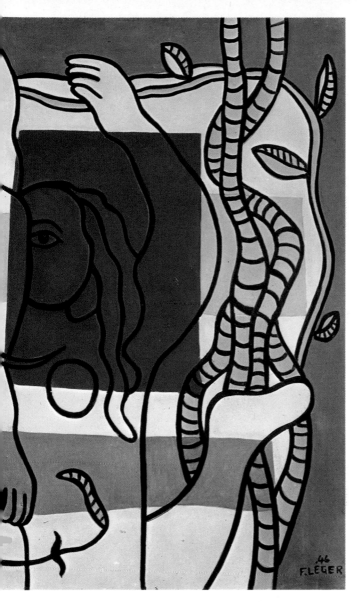

77 *Fernand Léger (1881–1955): Two women with flowers. 1946. Basle, Beyeler Gallery.*

artists in the two continents, to which both sides made important contributions. Moreover, it is from the common ground established by this dialogue that the basic trends of contemporary art have developed and defined themselves, making for a substantial unity of purpose and endeavour on both sides of the Atlantic.

The large number of European artists who emigrated to the United States on the eve of the Second World War included Léger, whose influence is most marked in the development of the taste for machine-like structures, Mondrian, and all the major architects and painters of the Bauhaus School. While Gropius was one of the key-figures in the evolution of American architecture, painters such as Joseph Albers and Moholy-Nagy had an important influence on the artistic formation of their young American contemporaries, even though the severe style of abstract art to which they remained attached in their new country attracted few followers. Together with Mondrian, they teach a respect for precision, perfect form and ordered composition.

There was, however, among the new immigrants a large group of Surrealists, including Ernst, Masson, Dali and Tanguey. Their activity prompted the development of an American Surrealist movement in which abstract art also had considerable influence and which was to emerge as one of the most significant contemporary movements in America.

Perhaps the greatest and the subtlest exponent of American Surrealism is Arshile Gorky. Rumanian by birth, though American by adoption (he emigrated to America in 1920), he went through an early Naturalistic phase, producing work that was conventional, though

78 *Joseph Albers (born in 1888) : Walls and screens. c. 1928. New Haven,*
property of the artist.

78 Joseph Albers (born 1888): *Walls and screens. c.* 1928. New Haven, property of the artist.
Although Albers's works are usually based on strict, geometrical calculations, their most important feature is their colour, which produces the most enchanting effects.

79 Joseph Albers (born 1888): *Study to told.* 1960. Milan, private collection.
Albers, a teacher at the Bauhaus School who later fled from Europe because of the Nazi persecutions, played a vital part in the introduction of neo-constructivist ideas into America.

80 Arshile Gorky (1904–48): *The orchard.* Turin, private collection.
The principles of Realism lie at the very root of Gorky's art and this can be seen in some of the details of his work; nevertheless we have the impression of some irresistible inner force compelling him to abandon all restraints, including the demands of exact and realistic representation.

81 Arshile Gorky (1904–48): *The Betrothal II* (detail). 1947. New York, Whitney Museum of American Art.
Gorky's discovery of Klee and Miró (and, one might add, Matta's influence on him in New York in 1939) caused a decisive break in his artistic development. But his commitment to Surrealism did not prevent him from regularly introducing numerous ideas reminiscent of his lyrical abstract period.

82 Roberto Matta (born 1911): *Morphological psychology.* 1938. Paris, private collection.
Though Max Ernst's work is gloomier, Matta's work also has a troubled, haunting quality. He is one of the most popular and highly regarded of modern painters.

83 Roberto Matta (born 1911): *Psychological morphology.* 1938. Paris, Galérie du Dragon.
Matta was trained as an architect and began to paint only in 1937. He created an individual style which was to prove particularly successful during and after the war.

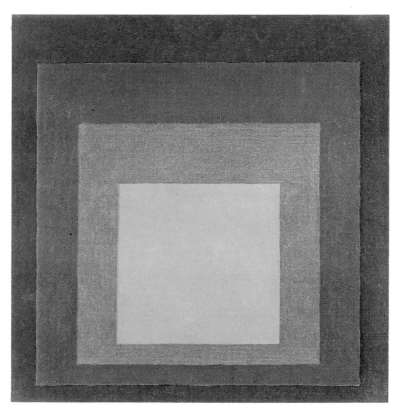

79 *Joseph Albers (born in 1888) : Study to told. 1960. Milan, private collection.*

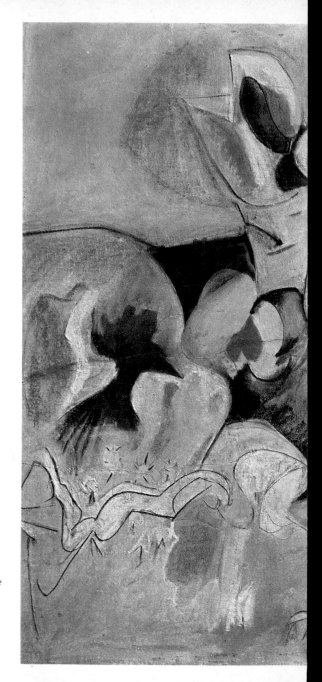

80 *Arshile*
Gorky
(1904–48) :
The orchard.
Turin, private
collection.

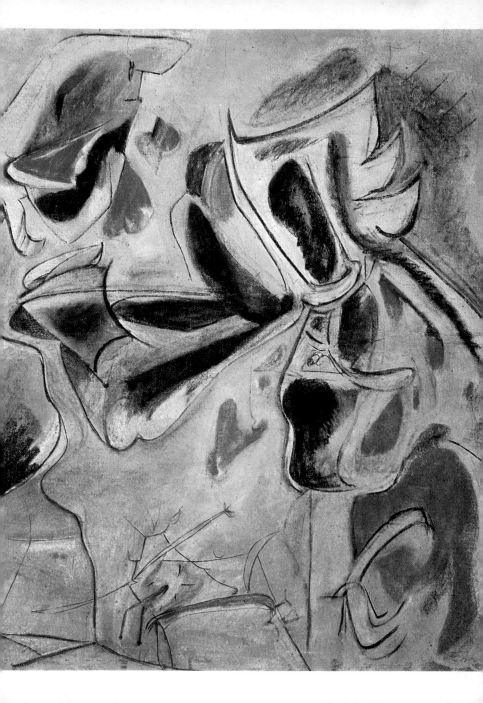

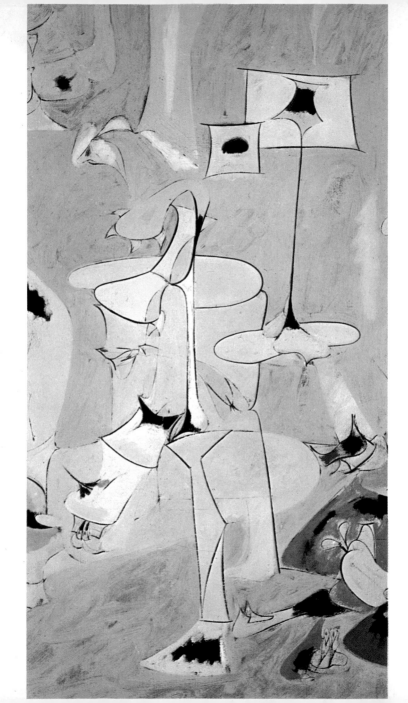

81 *Arshile Gorky (1904–48) : The Betrothal II (detail). 1947. New York, Whitney Museum of American Art.*

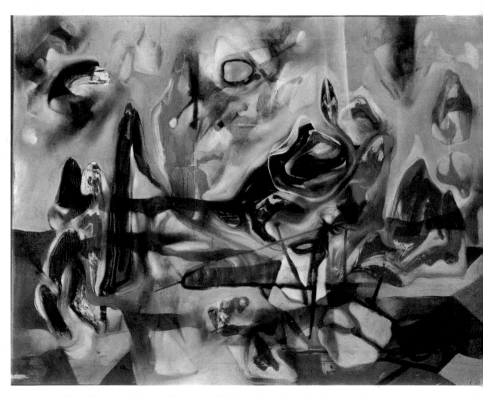

82 *Roberto Matta (born in 1911) : Morphological psychology. 1938. Paris, private collection.*

142

83 *Roberto Matta (born in 1911) : Psychological morphology.*
1938. Paris, private collection.

expressing a poignant sensibility. After 1930 he began to paint abstract art and here the influence of Cubism is quite evident. Gradually, however, as a result of his travels, the whole range of European art, from Picasso to Léger and from Kandinsky to Miró, began to permeate, enliven and enrich his work. Utterly dedicated to his art, Gorky reacted to these various influences in an original fashion and in the war years his poetic genius reached full maturity. His energetic interpretation of abstract art consists of echoes and images that seem to spring from the mysterious recesses of the Unconscious or the misty world of dreams. Gorky's painting is exuberant and violent, but both his frenzied glorifications of nature and the tragic poignancy of many of his paintings are pointers to that deep melancholy that led him to take his own life at the age of forty-four.

Whereas Gorky was basically an abstract artist who was nevertheless affected by Surrealism (and this is how his followers and his friend de Kooning, for example, regard him), the Chilean painter Matta's work is definitely Surrealist. His work is spontaneous and imaginative, finding its symbols in the secret mysteries of life, but at the same time the result of exceptional and adventurous technical ability.

Though a less original artist, Hans Hofmann has influenced the new generation as strongly as Matta. He was an American but had lived for many years in Paris in direct touch with the avant-garde groups, returning to New York in 1933 to open a regular school of painting. He was converted to abstract art at the beginning of the war and brought to this new style a violent, almost Fauvist use of colour and a restless sense of movement. There is some-

84 *José Clemente Orozco (1883–1949) : The white house (detail 1922. Mexico City, Carrillo-Gil Collection.*

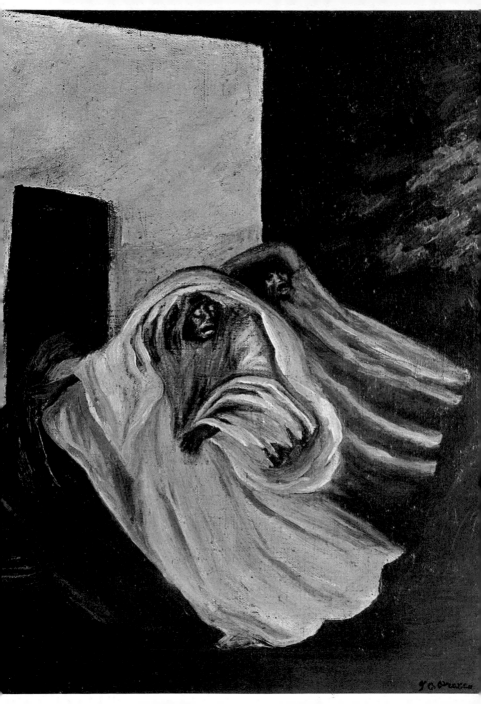

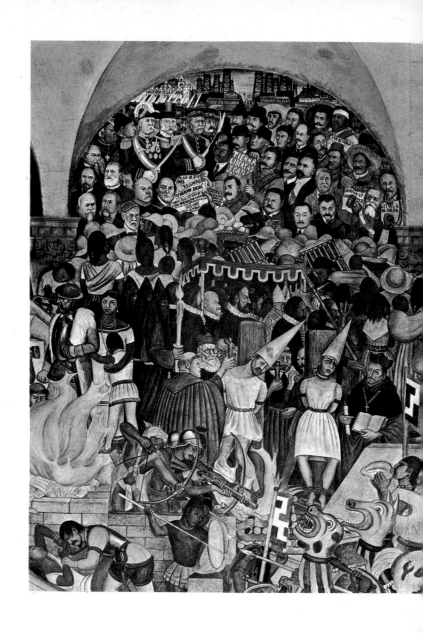

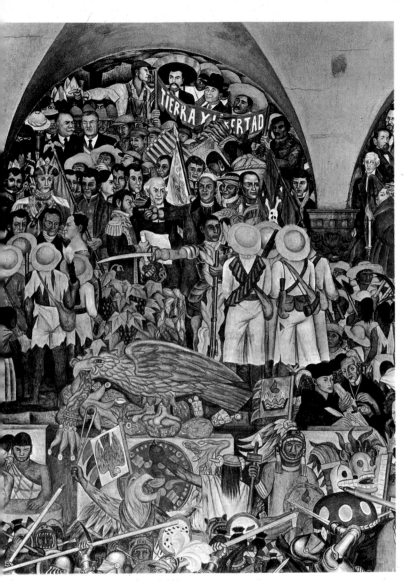

85 *Diego Rivera (1886–1957) : The Mexican War of Independence (detail). 1929–45. Mexico City, Royal Palace.*

84 José Clemente Orozco (1883–1949): *The white house* (detail). 1922. Mexico City, Carrillo-Gil Collection.
The tropical landscape of this painting of Orozco is seen 'to have a tragic nakedness in which historical conflicts appear like oppressive nightmares, or the passage of unleashed furies, or the feeble lamentations of death'. (Antonio Del Guercio).

85 Diego Rivera (1886–1957): *The Mexican War of Independence* (detail). 1929–45. Mexico City, Royal Palace.
The theme of this fresco, episodes from the Mexican struggle for independence, is taken from history, but the artist has expressed it without rhetoric or flourishes, as though the grand quality of the subject had no need of idealization for the viewer to experience its epic nature and heroic importance.

86 David Alfaro Siqueiros (born 1898): *Echo of a cry*. 1937. New York, Museum of Modern Art.
David Siqueiros has proved to be a particularly impressive and effective interpreter of the social and moral problems caused by war. His success is due to his ability to involve himself in the fundamental issues of contemporary art.

87 David Alfaro Siqueiros (born 1898): *Revolution against the Diaz dictatorship* (detail). 1957–66. Mexico City, Castle of Chapultepec.
This equestrian figure forms part of a composition which decorates the hall of the Castle of Chapultepec. Its complex rhythms break up the hall's rectangular symmetry.

86 *David Alfaro Siqueiros (born in 1898): Echo of a cry. 1937 New York, Museum of Modern Art.*

148

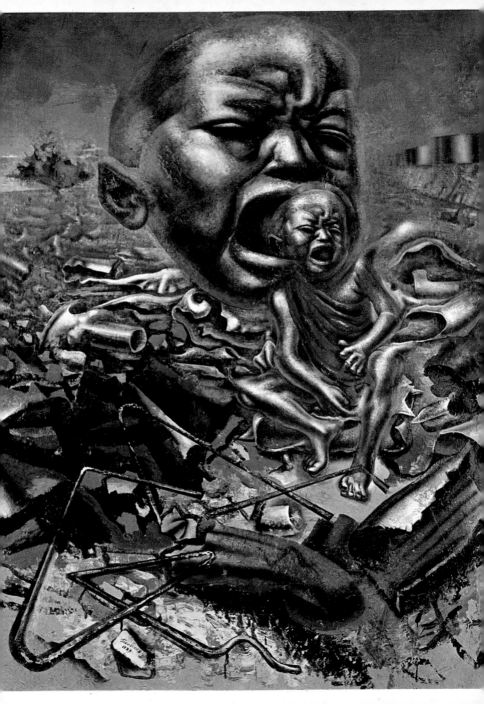

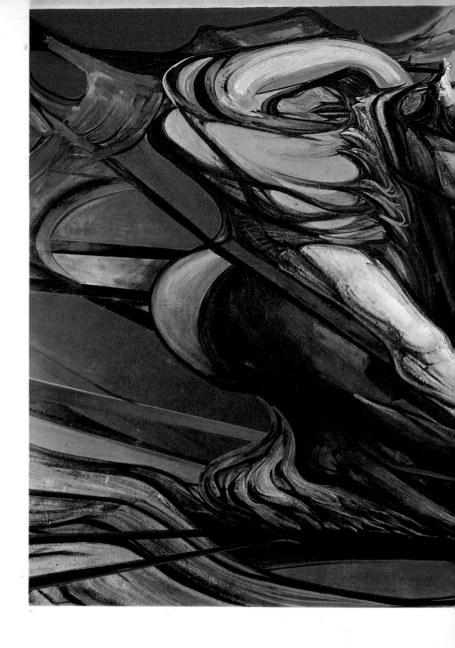

87 *David Alfaro Siqueiros (born in 1898) : Revolution against the Diaz dictatorship (detail). 1957–66. Mexico City, Castle of Chapultepec.*

thing deeply symbolic in the colourful magic of his pictures, foreshadowing the famous free creation of Pollock and the school known as 'action painting'.

In addition to the various manifestations of Realism, which, though sometimes very important (as in the case of Ben Shahn), are always isolated, painting in America, as in Europe is dominated by abstract art. There is also a rebellious strain in American painting, a need for spontaneity in self-expression which is obtained by genuine improvisation and a belief in the necessity of liberating feelings from the prison of the subconscious. This belief derives from Surrealism, though here it has been rediscovered and redefined.

Mexican Realism

There are three Mexican painters who deserve separate treatment in this survey of modern American painting. All three have brought vigour and fresh life into Mexican art thanks to the poetry and social significance of their work. Diego Rivera, Clemente Orozco and Alfaro Siqueiros are the leaders of a new artistic movement which, though fully aware of the advances and achievements of contemporary European painting, prefers to look to its own artistic tradition and to revive the inspiration and the art of the ancient pre-Colombian civilizations.

Rivera spent several years in Paris, where he took an active part in the revolutionary art movements of the early twentieth century, and may have been more affected by European traditions than the other two. Siqueiros is more interested in theory and has shown a penetrating insight into stylistic problems. Orozco, on the other hand, has been single-minded in his attempts to creat an art for, and

inspired by, the people. But all three of them share three qualities – a love for their country and its traditions, an understanding of the difficult period through which their nation is passing, and a deep commitment to the world in which they live, a commitment which compels them to use their art as a political weapon (as in the Mexican Revolution of 1910).

Their work has a genuine epic quality which is rarely to be found in the twentieth century. It often takes the form of vast compositions – frescoes and murals which are so appropriate to the deep epic feeling of excitement and passionate celebration which they are trying to convey, bringing to life groups of figures that are full of dramatic tension. This tension is most obvious in the work of Alfaro Siqueiros, who worked out a new kind of realism, intended to combine objectivity and subjectivity. The result is rather like a new brand of expressionism which makes frequent use of repeated images.

In Brazil, Candido Portinari plays an almost identical role to that of these three Mexican painters. He too has committed himself to reviving the spiritual qualities and traditions of his country, though he seeks to convey them in a contemporary manner.

BIBLIOGRAPHY

W. ANDREWS, *Architecture in America, New York 1960*

W. ANDREWS, *Architecture in Chicago & Mid-America, New York 1968*

W. ANDREWS, *Architecture in New York: A Photographic History, New York 1969*

R. CORTISSOZ, *American Artists, New York 1923*

L. GOODRICH & J. L. BAUR, *American Art of Our Century, New York 1961*

L. KIRSTEIN & J. LEVY, *American Art of the Twenties & Thirties, New York 1970*

J. MILLAR, *Architects of the American Colonies, New York 1968*

B. ROSE, *American Art since 1900, New York 1967*

E. SPAETH, *American Art Museums, New York 1969*

M. WHIFFEN, *American Architecture since 1780: A Guide to the Styles, New York 1969*

LIST OF ILLUSTRATIONS